THE TURNER PRIZE
AND BRITISH ART

THE TURNER PRIZE
AND BRITISH ART

First published 2007 by order of the Tate Trustees
by Tate Publishing, a division of Tate Enterprises Ltd,
Millbank, London SW1P 4RG, www.tate.org.uk/publishing

British Library Cataloguing in Publication Data
A catalogue record for this book is available from the British Library

ISBN 978-1-85437-742-5

Designed by BC, MH
Printed by Cambridge University Press

Front cover: Installing Damien Hirst's *Mother and Child Divided* for
the Turner Prize exhibition in 1995. Photo: Philip Pestell
Frontispiece: Peter Clarke *Guardian* 6 November 1984. Guardian News
& Media Ltd

All dimensions are given in centimetres, height before width, unless
otherwise noted.

CONTENTS

FOREWORD

As a juror in the first year of the prize and as Chair of the jury since 1988, I have been too closely involved with the Turner Prize to have an impartial view. However, the high profile of so many of the winners, especially of those who were almost unknown at the time, coupled with the strength and depth of the list of those who have been shortlisted, goes a long way to explaining why the Turner Prize continues to command international attention and respect. Put simply, in recent years the UK, and London in particular, has become one of the most significant centres of production in the contemporary art world.

In Britain we live in a society that, broadly speaking, welcomes newcomers. Opening doors to economic and political migrants as well as our art schools to students from across the world has been beneficial to the visual arts in this country. New art flourishes where different streams of consciousness meet. Paris in the early years of the twentieth century, Berlin in the 1920s and New York during and immediately after the Second World War provided such meeting points. London, it can be argued, is now such a centre.

The Turner Prize has become a forum for debate about contemporary art, but the public response and growing enthusiasm for contemporary art have been stimulated largely by the strength and resonance of the work on view. Furthermore, the authority of the prize has been enhanced by the ability of artists whose work has appeared in a prize exhibition to go on developing their work. Tate attracts a wider audience than most galleries dealing with contemporary art and, through the alliance with Channel 4, the Turner Prize has given many artists a chance to present their work to a broad public at a much earlier stage in their careers than would previously have been the case.

The result has been a steadily growing public awareness that art takes many forms and addresses issues beyond the conventions of representation and 'beauty'. Gradually press reaction has become more thoughtful as commentators recognise that artists like Antony Gormley, Anish Kapoor or Rachel Whiteread, initially regarded as elite or obscure, can produce sculpture that touches a surprising nerve in a wide range of people.

Of course, every year the judgements made by the jury are invidious. The decisions are those of a changing group of individuals whose enthusiasms are much more diverse than the press sometimes recognises. Why else would an artist who has been overlooked by a jury one year be in fierce contention the next, as has happened on several occasions? I cannot repeat often enough that the result each

year depends on the chemistry of the four individuals meeting twice over a period of months, and responding both to each other and to what artists place before them. In the end it is not a lottery, because closely argued opinions win the day, but in any one year it is highly subjective.

Over a twenty-year period, however, the picture evens out, and the work of those shortlisted, as well as the winners, demonstrates the abundance of creativity and imagination in the visual arts in Britain today. In spite of the international recognition of artists such as Blake, Turner, Constable, Bacon and Moore, it is often said that the British are a literary rather than a visual nation. In the late twentieth- and early twenty-first century the vitality of the artists showing in the Turner Prize has demonstrated that we are visual as well as literary, even if we have come to value our artists rather late in the day.

Nicholas Serota
Director, Tate

1984 Turner Prize jury, from left to right: Rudi Fuchs, Felicity Whaley-Cohen, Alan Browness, Nicholas Serota and John McEwen

THE TATE, THE TURNER PRIZE AND THE ART WORLD

LOUISA BUCK

On 1 January 1980 Alan Bowness succeeded Norman Reid as Director of the Tate Gallery. The new decade ushered in a period of significant change for the Tate, which would unfold in tandem with a radical transformation of the wider contemporary art world. Over the next twenty-five years, first under Bowness and then gathering momentum when Nicholas Serota assumed the Directorship in September 1988, the Tate Gallery on Millbank would expand, divide and rebrand itself as Tate, the four-headed world-renowned institution we know today. At the same time London was also changing, from a small-scale local artistic backwater into an international art centre and the European hub of the global contemporary art market, worth more than £500 million a year.[1]

A key factor within both the evolving Tate and the burgeoning British art scene has been the Turner Prize. From its inauguration in 1984 up to the present, the Turner has assumed several different incarnations and its relevance and purpose have been constantly under review. Tracking the Turner's development reveals how, in ways both subtle and overt, this prize has been closely tied in with the changing image and profile of Tate as well as reflecting, responding to and having repercussions on the art world at large.

At the beginning of the eighties the Tate was still reeling from the controversy surrounding the gallery's purchase of Carl Andre's *Equivalent VIII*. The public outcry over 'the Bricks' had been triggered by an article in the *Sunday Times* in August 1976 about recent acquisitions for the gallery's collection, and the ensuing storm of protest resulted in a climate of caution at the Tate, which in spite of a series of pioneering exhibitions in the decade before,[2] by the early eighties had fallen behind in its presentation of contemporary art.[3] The Tate's lack of engagement stood in sharp contrast to the progressive exhibition programmes of organisations such as the ICA, the Riverside and the Whitechapel, as well as groundbreaking shows such as *The New Spirit in Painting* organised by Norman Rosenthal, Christos M Joachimides and Nichola Serota for the Royal Academy of Arts at the beginning of 1981.

The situation was further compounded by the fact that the Tate was also strapped for cash. During the seventies there had been a substantial rise in grant-in-aid for acquisitions but since 1980 there had been no real improvement, and the prognosis for future public funding was gloomy, especially since the election of Margaret Thatcher as Prime Minister in 1979. As the *Tate Gallery Illustrated Biennial Report* for 1982–4 ruefully remarked, 'It becomes increasingly difficult

for the Tate Gallery to compete for the limited number of outstanding works.'[4] At the same time, in an attempt to reposition the Tate within the contemporary sphere, Bowness and his Trustees expressed their intention to push through plans to establish a 'Museum of New Art' which would be 'devoted to contemporary art, as an integral but distinct part of the Tate Gallery,' and for which an active acquisitions policy would be essential to make the collections 'as rich and comprehensive as possible.'[5]

For Bowness, the solution lay in private sponsorship. In 1982 he established the Patrons of New Art (PNA), a subgroup within the existing Friends of the Tate which would be limited to 200 individual members with the aim 'to encourage a lively and intelligent interest in new developments in art, and in particular its collection, both private and public.'[6] Not only would the PNA save the Tate from the another 'Bricks' scandal by funding the acquisition of potentially controversial younger artists for the Tate's contemporary art collection, but their purchases would form the nucleus for the Museum of New Art, 'the first public gallery in Britain devoted to the collecting and exhibiting of new art.'[7]

However, the Tate and its newly formed Patrons group soon learnt that the potentially sensitive interface between the private and the public sector also needed careful handling. In the summer of 1982 it provoked a critical outcry by mounting a small exhibition of eleven paintings by the young American artist Julian Schnabel, without adequately acknowledging that nine of them belonged to the collector and founding PNA committee member Charles Saatchi. Saatchi resigned from the PNA shortly afterwards.

It was amidst this sensitive and potentially volatile climate that the Turner Prize was born. In their early meetings the PNA decided that a way 'to encourage a lively and intelligent interest in new art' - and also to raise their profile as an organisation - would be to establish an annual art prize, along the lines of the Booker Prize.[8] In the same way as the Booker boosted new novels, it was hoped that an art prize would promote contemporary art to a wide audience. It would also provide a means by which the Tate could be seen to be engaging with the latest in contemporary art without spending any taxpayers' money.

It was decided that the art prize would be awarded to the person considered to have made the greatest contribution to art in Britain during the previous twelve months. Oliver Prenn, a businessman and founder member of the PNA, agreed to be the anonymous sponsor of the prize, with his charitable foundation funding it for its first

three years at £10,000 a year. 'It wasn't about me; what was important was that it should be a Tate prize and a Tate Patrons prize, which was a new body and needed to be put on the map,' Prenn recently recalled. 'There was this great vacuum surrounding contemporary art – we wanted to get the public and collectors interested and boost something that wasn't at all popular. We hoped that the Turner, like the Booker, would become a much-discussed annual event.'[9]

The first Turner Prize seemed set to achieve this aim. Debate raged from the outset, both within and outside the Tate, over the harnessing of Turner's revered name to a new art prize, especially since Turner's own bequest for a young artist's prize had never been implemented.[10] The presentation by flamboyant Minister for the Arts Lord Grey Gowrie was televised by BBC 2's *Ominbus* programme, and there was another flurry of protest when Malcom Morley was chosen as the winner of a British art prize, having been resident in New York for the past twenty-six years, especially when it emerged that he had served a short prison sentence in his youth. As Oliver Prenn was to recall, 'the choice of an ex-convict living in America was a perfect stimulus to public controversy and debate... The prize established itself instantaneously and in a manner exceeding our wildest expectations.'[11] With the safeguard of the Turner being privately funded by a nameless patron, the Tate was able reap the benefit of the prize's profile-raising controversy without any adverse consequences.

However, subsequent Turners failed to build on this promising start, and the prize's struggles to find a lasting format and identity during the latter part of the 1980s dented its credibility, and proved increasingly problematic for the Tate. The rules kept changing, to the extent that the only consistent feature of the prize seemed to be its changeability, while at the same time the choice of artists often seemed stale and predictable, with the same names repeatedly cropping up on its shortlists. (All five original 1984 nominees went on to win the prize, three of them in the following three years: Howard Hodgkin in 1985, Gilbert & George in 1986, and Richard Deacon in 1987.) No age limit for nominees meant that established figures were pitched against relative newcomers;[12] and the mix was further confused by the occasional appearance of other art-world figures apart from artists on the shortlist.[13] The prize's role as a showcase for new art was further compromised by difficulties over timing, lack of budget, and a shortage of space, which meant that the presentation of the shortlisted artists' work varied from year to year.[14]

Grey Gowrie at 1984 Turner Prize Awards ceremony

When Nicholas Serota became Tate Gallery Director in September 1988 he considered dispensing with the prize altogether. From his previous vantage point as Director of the Whitechapel Gallery (and a member of the first Turner Prize jury) he recalled that 'it seemed that maybe the Tate was using the Turner Prize as a way of discharging its responsibilities by seeming to embrace contemporary art without having to endorse it or commit to collecting it systematically.'[15] He was also opposed to the shortlist, believing that 'the announcement of a shortlist causes anguish to artists without giving compensating edification to the public. There is a sense of a horse race between unevenly handicapped mounts, and disappointment and embarrassment at being a senior artist who is good enough to run, but not to win.'[16]

Serota eventually decided to keep the Turner, but to make it an artist-only prize, and to abolish the public announcement of the shortlist. However the loss of this media-friendly element only acted further to diminish the Turner's status, both within and outside the art world. By 1990, when the Turner Prize was suspended due to the bankruptcy of the American investment company Drexel Burnham Lambert, which had taken over the sponsorship at the end of Prenn's three-year term in 1987, Serota ruefully conceded that the hiatus was 'unsought but not perhaps unwelcome.'[17] Critic Matthew Collings took a somewhat harsher view, summing up the situation as: 'Nobody listening: Turner Prize out in orbit and talking to itself.'[18]

The decline of the Turner was sharply at odds with what was proving to be a dynamic new era for the Tate. In the first year of his directorship Nicholas Serota energetically set about restructuring the Tate's staff, redefining its aims and instigating an annual re-hang of its collection. No longer were new developments in art to be sidelined. The primary aim of the Tate was now 'to improve public awareness, understanding and appreciation of British painting from the sixteenth century to the present day, and of international twentieth-century painting and sculpture.'[19] The ways in which this was to be achieved included 'promoting the collection to a wide variety of audiences, ranging from the first-time visitor to the scholar,' and 'collaborating with artists in the presentation, acquisition and documentation of their work, seeking to promote understanding and appreciation of the art of our time, as well as that of the past.'[20] Under Serota, the Tate had entered the modern world, and one in which the private sector was to play an ever more prominent part, as demonstrated by the establishment of a development office, 'to strengthen the support

for the gallery from individuals, trusts, foundations and companies' both in the UK and beyond.[21]

For the Turner to have a relevant role within this new regime required a radical rethink, and when the prize was relaunched in 1991 it had been subjected to a substantial makeover. The catalyst for change was a new sponsor, Channel 4, whose Commissioning Editor Waldemar Januszczak believed that: 'There is no doubt that the Turner Prize is Britain's most prestigious art award. But there is no doubt that the prize has never fully realised its potential as whipper-up of enthusiasm and understanding for new art. To be perfectly honest there have been years when it has hardly seemed worth going to the trouble of having the prize at all. And yet … there is no doubt that something important about the Turner Prize survived the attacks and the confusions. It's not perfect – but it's the best there is. And because it's not perfect it has, in my opinion, a future full of potential.'[22]

The Tate and Channel 4 devised a clear and consistent format for the 1991 Turner Prize which, bar a few adjustments, remains largely unchanged to this day. Henceforth the prize would be awarded to a British artist under fifty for an outstanding exhibition or other presentation of their work in the previous year. The prize would be increased from £10,000 to £20,000, and presented at an awards ceremony held at the Tate Gallery. Channel 4 would make documentaries about the shortlisted artists' work, and the awards ceremony would be televised live.

The shortlist was reinstated and set at four artists, with Serota conceding that, 'I had to accept that if you were going to have a competition then you had to have a shortlist, and I set about trying to make the shortlist as dignified and as rewarding to each of the shortlisted artists as possible.'[23] Both Tate and Channel 4 were convinced that mounting a carefully curated exhibition of the shortlisted artists' work at the Tate Gallery prior to the winner being announced was a key element in establishing both the credibility and the impact of the prize. Serota also hoped that a proper exhibition would go some way to compensate for the inevitable strain that a televised prize would impose on the shortlisted artists, declaring that, 'Making the exhibition more serious meant that even if they [didn't] win the prize, an artist [would] get a fair opportunity to show their work, and it [would] be reasonably well-presented.'[24]

The inauguration of a younger, leaner Turner that was closely tied in to the mass media chimed with developments that had been taking place throughout the wider art world as well as

within the Tate. By 1991 the group of New British sculptors who had emerged from the Lisson Gallery at the beginning of the 1980s (including Tony Cragg, Richard Deacon and Anish Kapoor) had put British art firmly on the international map, and now the next generation of artists, focused around recent Goldsmiths' graduate Damien Hirst and his contemporaries, was poised to take the art world by storm. These artists were barely out of art school but already making waves, mounting exhibitions of their own work in empty industrial buildings,[25] joining forces with young dealers and curators,[26] and - crucially - catching the eye of collector Charles Saatchi.

Saatchi's spending power had been a key factor in revitalising the British art scene during the sleepy early eighties, and this continued apace throughout the next decade. The first Saatchi Gallery, which opened in a former paint factory in Boundary Road, North London in March 1985, had revolutionised the way contemporary art was viewed in this country, with its 30,000 square feet of dazzling white space (designed by PNA founder Max Gordon) and institutional-style exhibitions programme, which showcased his extensive holdings in established and emerging American, European and American artists.[27] Saatchi had attended Hirst's famous *Freeze* exhibition in 1988, and soon began to bulk-buy this new batch of home-grown talent. He also set about applying his marketing skills to the promotion of these artists and their work, initially in a series of widely publicised exhibitions at Boundary Road during 1992-5 under the collective title of Young British Artists.[28] The acronym stuck, and soon any artist of that generation, whether or not they had been to Goldsmiths', was branded YBA.

The 1991 Turner Prize reflected the arrival of this new artistic generation. On the shortlist were three artists in their twenties: Rachel Whiteread, Ian Davenport and Fiona Rae (the last two Goldsmiths' graduates) with Anish Kapoor, the winner, seeming very much the elder statesman, although he was only thirty-seven. Amidst inevitable accusations of trendiness, the general consensus was that the Turner was back with a vengeance. 'When the young artists started winning it was so exciting,' remembers gallerist Nicholas Logsdail. 'Whatever the outcome, everybody was infected and energised by this excitement.'[29]

From apologetically dithering on the margins, the Turner swiftly established itself as a key fixture within an increasingly dynamic UK art scene. Throughout the 1990s the prize genuinely fulfilled its first sponsor's aim of becoming a 'much-discussed national event,' with the announcement of every shortlist accompanied by a media

Damien Hirst, 1993

Charles Saatchi

feeding-frenzy, fanned by the live coverage on Channel 4. As British art boomed, the Turner reflected its most conspicuous players as well as giving other, quieter artists a chance to occupy the spotlight.[30]

The profile and prestige of the relaunched Turner was greatly to the Tate's benefit. Undeterred by the adverse economic climate following the stock market crash of 1992, the Tate was forging ahead with its plans to expand. The Tate Gallery in St Ives opened in June 1993, and the following year the Trustees announced their intention 'to create a new Tate Gallery of Modern Art in London, using the former Bankside Power Station opposite St Paul's Cathedral,' with the existing Millbank site becoming the 'Tate Gallery of British Art.'[31] In order to achieve this considerable feat and keep both private and public funders on board, it was important for the Tate to project not only institutional gravitas, but also the sense that it was acknowledging and engaging with Britain's art boom.

By the second half of the 1990s the economy had picked up, and the market for contemporary art was gathering pace. London was on its way to becoming an international market centre. Energetic young dealers such as Jay Jopling and Sadie Coles were making their mark, more established contemporary art galleries such as Lisson and Victoria Miro were expanding their spaces, and the price of contemporary artworks began its upward spiral. The auction houses were also adapting their modus operandi to take advantage of the increased interest in new art, and in 1998 Christie's set a new pattern by mounting an auction of young artists in the appropriately gritty setting of a Clerkenwell warehouse.[32]

Even with the best efforts of the Patrons, in this fast-moving market it was difficult for the Tate to compete with private individuals to purchase new work. The Turner was therefore a useful way to present the latest art without actually having to own it (although in time the Tate often did acquire work by Turner-shortlisted artists). An additional showcase for new art was the Art Now project space, which opened in 1995, but overall it became increasingly obvious that the Tate desperately needed to expand its facilities for showing new developments in art. The success of the Turner only highlighted the situation. As Nicholas Serota was to comment, 'The energy that the Turner Prize exposed in contemporary British art in the 1990s pointed to a need for a more expansive, more explosive, place in which to look at contemporary art. The fact that it could not be contained in this relatively small building on Millbank definitely encouraged people to get behind the idea of creating Tate Modern.'[33]

The Queen and Bridget Riley at the
opening of Tate Modern, 2000

Yoko Ono presenting the 2006 Turner Prize

The opening of Tate Modern in May 2000 marked the international coming-of-age of the British art world, and signalled the transformation into Tate, a national organisation with four galleries sharing a single collection. The Turner continued to be shown at Tate Britain, the site devoted to British art, and in the early years when all eyes seemed to be on Tate Modern, helped to redirect some of the spotlight back onto Millbank from across the river. From the outset Tate Britain had been at pains to stress the historic internationalism of British art, and this aim chimed with the clarification of the Turner's terms in the mid-1990s, as a prize that awarded both British born artists and 'foreign born artists living and working in the United Kingdom'.[34]

The beginning of the new millennium has seen the Turner Prize settle into an established pattern. While there are still occasional flurries of controversy – Madonna swearing on live TV before the 9 p.m. watershed in 2001 as she presented the prize to Martin Creed for his *Work No. 227, The Lights Going On and Off*; or a hostile outburst by a Government Minister in 2002[35] – consistently high attendance figures and more serious treatment from most of the media are testament to the fact that the Turner in particular, and contemporary art in general, have both now been assimilated into the cultural mainstream. As audiences become ever more sophisticated, the howls of outrage that emanate from certain quarters of the press if an artist uses unorthodox materials now seem contrived and irrelevant, especially as the production of art is increasingly seen as part of a multi-million global economy supported by a network of art fairs, Biennales and galleries public and private.

The fact that the Turner is now part of a more professionalised art world has been demonstrated by some low-key but significant changes that continue to play a part in shaping the prize and its impact. Although they continue to cover the event, Channel 4's sponsorship of the prize came to an end in 2003 and was replaced by Gordon's Gin (owned by Diageo PLC). Gordon's doubled the prize money to £40,000 but, in a significant shift away from the 'first past the post' format, Tate decided to award some of that to the shortlisted artists, who now each receive £5,000. The involvement of the Patrons of New Art has also been reassessed. Since 2005 there has been no Patron on the Turner jury, and they no longer play a part in selecting the judging panel, which is now handled solely by Tate. With many of the PNA's membership consisting of collectors, gallerists and art professionals, it is now deemed more appropriate that they keep their distance from the workings of the prize.

So what does the future hold for this more sober, serious Turner? Today it is just one amongst a plethora of prizes for contemporary art, many of which have followed in the footsteps of the Turner in bearing the names of great artists, from the Vincent in Holland and the Duchamp in Paris to the Miró in Spain. Yet just as the Booker (now Man Booker) is still the most celebrated literary prize, so the Turner remains the best-known and most prestigious in the art world. But it cannot afford to rest on its laurels. Now that galleries both public and commercial market their artists with increasing sophistication, and the current state of the market means that artists can make enormous sums of money from the sale of their work, much of the prize's original remit to highlight and reward new work is being carried out elsewhere. For their part, the Tates Britain, Modern, Liverpool and St Ives now have a wide representation of contemporary art in their exhibition programmes, so Tate no longer has to rely on an annual prize to be seen to be keeping in touch.

The establishment of the Frieze Art Fair in 2002 has also altered the London art scene beyond recognition. In the past the Turner opening and awards night were always the main events in the British art calendar, but to a great extent they have been demoted by this new arrival. In a remarkably short time, Frieze has positioned itself not only as a major international art fair, but also as a significant cultural event in its own right. In addition to the participating galleries and the programme of artists' projects and activities programmed by the fair itself, Frieze has spawned a multitude of satellite events. Galleries large and small, private and public (including Tate), now all schedule their programmes with Frieze in mind. Sotheby's and Christie's organise their contemporary sales to coincide with the fair as, during what has widely become known as 'Frieze week', the international art world converges on London, attracting wide media coverage and tens of thousands of visitors.[36]

It could be argued that the jamboree surrounding Frieze, and the huge public interest in contemporary art, has released the Turner Prize from its increasingly irksome obligation to offer up an annual spectacle in the name of art. However, the abiding concern is that if it loses its prime purpose of presenting younger artists' work to a broad public, it runs the risk of settling into a weary predictability. To prevent this, we need to remember that the prize owes much of its impact and enduring status to its unique fusion of the gravitas of a public institution with the unpredictability of new art. Both sides of this equation should therefore be maintained. Now there is so much

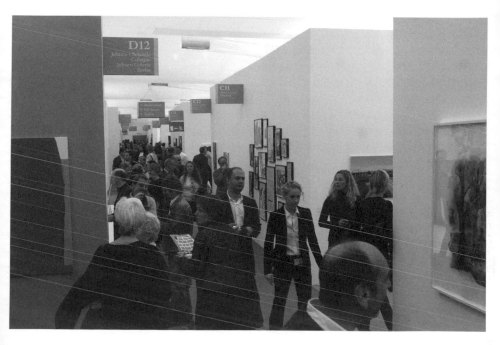

2005 Frieze Art Fair

more new art on show, in so many different contexts, it is vital that the Turner continues to highlight and defend the very best. If the prize continues to be associated with art that is 'outstanding', the Turner stands a good chance of remaining relevant and keeping its rude good health.

A DISCUSSION ABOUT PRIZES

MARK LAWSON ML
GRAYSON PERRY GP
LIONEL SHRIVER LS

ML Since both of you have benefited from prizes, let's start from the obvious place; in general do you think prizes are a useful and good thing?

GP I think that there is so much going on in the cultural landscape today that I get bewildered, I get overload[sic], and so prizes pick out things perhaps that are of high quality or worth seeing.

LS I think they provide a template. Literature is not really different from visual art. You are dealing with this ongoing deluge of publishers putting out lists, and not even in co-ordinated sequences, just simply a bunch of new books all of the time. There is no moment to consider what has been submitted to the cultural marketplace apart from a few other points, such as the end-of-year newspaper reviews. Prizes are the only other occasion in the cultural year when you can get a sense of focus on what is important ... Although it is not going to be always a just process. There are lots of people who are going to be overlooked and they are going to be mad about it.

ML That is important, because whereas for the hundred metres you can judge scientifically who is the fastest person in the world, and you can check if they are on drugs, and so it's relatively fair, the reason people object to prizes is that it's a group of people that get together to make decisions, which may or may not be influenced by who they like, who they hate, who they know.

GP But the judgement of art is always subjective, so why not just recruit a few experts and get them to flag up what they think has merit? You can't hold a ruler next to a work of art and say 'This is the best work of the year'.

LS I think one of the best things that comes out of the process of prizes is the discussion around it. Sometimes the irony around it, about who has been left out or what 'rubbish' has been elevated, creates a useful conversation. It generates energy, and to have a market for art you need that energy, you need the public interest, and sometimes that takes the form of outrage.

ML The reason people who are not shortlisted get so bitter, I suppose, is that it can have such an astonishing effect. There are authors who are literally millionaires as a result of prizes,

particularly the Richard and Judy Prize, which is a good example. A single producer sits and chooses twelve books a year, and those authors are guaranteed now to become millionaires at the very least. It's an awful lot of power for someone to have, isn't it?

LS Yes, it really is. It's the same thing in the States with Oprah. If you are left out, it's easy to say 'Oh, this isn't just.' Of course it has nothing to do with justice.

GP People always say it's a mafia in the art world, and I always say, 'Yes, it's a mafia that lets in Essex transvestites.' If you are from the outside it's always going to look like a closed shop until you are in, when it suddenly seems amazingly meritocratic.

ML That's what the actor Bill Murray said at the Golden Globes, that he'd always thought prizes were a terrible and unfair thing until he'd been nominated for a Golden Globe, when he changed his mind. That is an obvious human reaction, though, isn't it?

LS Yes, but I think what you are probably doing ultimately is selling more books or selling more art.

GP I think the Turner Prize is different from that slightly, as there is no popular win of art consumption. I mean people go to exhibitions, but I don't flog millions of works to people.

ML Being shortlisted for the Turner Prize, what does it do to your price?

GP Well, mine didn't bump up immediately at all. I was quite cynical about it. Actually, I thought it would have almost a negative effect on my coolness factor and my desirability within the art world, because I thought maybe the Turner Prize was seen as a bit tacky. I've changed my mind since then ... I was talking to people recently, especially abroad, and the Turner Prize has a very good reputation because it has a good strike rate with artists who are well regarded in the wider art world. So it is an indicator, but there are so many factors that make a success in the art world. It's a much more subtle consensus than a small judging panel deciding this person is going to be good for all time.

ML One of the ways it works, I've found as a journalist and broadcaster, is that it just gives a tag, because one of the problems is that most of the audience don't know who anyone is, which is understandable. So once you become Turner Prize-winning artist or Orange Prize-winning author or whatever, it says this person is important.

GP I have a kind of quadruple-barrelled name now, Grayson-Perry-Turner-Prize-winner, because that's how I am always introduced.

LS I think for me being tagged with the Orange Prize is a little uncomfortable. Of course I'm delighted to have won something, and I'm old enough to take whatever I can get. But if I could choose, it wouldn't be the prize that I would tag myself with because, of course, it's a women-only prize.

ML There are some people who say that it shouldn't even exist for that reason. That it may even be illegal under anti-discriminatory laws.

LS I'm glad I got one of the last ones [laughter]! Yes, I am ambivalent about the whole phenomenon as it doesn't really represent the way I think. I don't think in terms of gender when it comes to literature. I prefer it not be separated into men's work and women's work. I would certainly prefer to win an award that included both men and women.

ML Well, I want to talk about the hierarchy of prizes. It's interesting because we are talking in the week of the Oscar nominations. That remains the ultimate prize, I think, doesn't it?

GP I think it's a calling card practically anywhere on the globe. On the strength of winning the Oscar I think you can probably pick and choose what work you want to do for the rest of your life, just because everybody wants to be associated with that.

ML In literature the Oscars in Britain would still be Man Booker and then what used to be the Whitbread, but is now the Costa, so coffee replacing beer. It's interesting that people rate these higher than much more financially rewarding prizes. I think the IMPAC Award is £50,000 or so, and I think the MCR one for non-fiction is more.

LS Yes, there has been an effort to buy prestige. If you are putting money out there you think you are going to get the press. To some degree that's true, but to a surprising degree, it isn't. The Man Booker has an 'X' factor to it, and it can keep stodgily paying whatever it pays now, but it will still be the Booker.

GP But there is the ultimate literature prize, the Nobel, which is a huge amount of money. It's like a quarter of a million quid or something, isn't it?

ML It's about half a million. It depends on the exchange rate, but it's about £600,000.

GP That's the one to go for! [laughter]

ML But that's interesting, when you see someone like Harold Pinter or Seamus Heaney, you do feel a sort of awe that they have won the Nobel Prize.

GP Yes, and I don't know whether that's age. I mean, there's a kind of irony, you know, it being from a TNT manufacturer somehow as well [laughs].

ML But there are so few of them, in any one country it would be amazing if there were even two of them alive at one time, so it feels very special in that way.

GP Yes, and the line-up of people who have won it. That is what adds to a prize's kudos, the list of past winners.

ML I wanted to ask you about that. Were there any that you didn't fancy being in the company of when you looked at the people that had won the Turner Prize?

GP I think there have been a few default winners who were everybody's second choice – and I might be that person myself. I think the problem when you have a jury is that you can have a polarised jury, and then there's a high chance that everybody's second choice is going to win.

ML That's interesting. I have been on quite a lot of judging panels, and I can't imagine you, actually either of you, being a compromise choice. I think you must have won them clean, because there are people who would take against both your work, and it's very hard to come through as a compromise candidate in that way. I suspect it was probably a straight knockout.

GP That's okay, I'll take that [laughter].

ML But the Nobel presents another issue, which is who should judge these things, because the Nobel is the same people every year until they die. People have suggested that for the Turner Prize, for the Booker, for all of them, that if you had the same people every year then you would at least know whose taste you were judging against.

LS Would you want the same tasters?

GP I like the fluctuation. I like the fact that the Turner Prize has almost had three different ages. First it went through this age when it dished out the prize to the old guard, the people who were just getting a bit too old for it maybe. Very fortunately for the Turner Prize, I think, there was the sort of Saatchi YBA phenomenon that came along just in time to really inject it with 'pizzazz', and that was really the golden era in many ways of the Turner Prize, and now it is kind of established so we can dish it out to younger, less well-known artists. In fact, the prize is more famous than the artist, whereas there was a point where the artists were more famous than the prize, I think.

ML Another question that arises is eligibility, because every year when the Turner Prize shortlist is announced we get phone calls from people saying they're not really eligible because they are really German or live in Poland, and all these prizes have complicated rules. You have this issue, [Lionel], as an American living in the UK, so you are eligible for some and not others, I expect?

LS Yes, that's why I can't win the Booker, since I am not a citizen of the Commonwealth and that's the criterion. That's why they brought in the International Booker. But it's interesting that the International Booker has not been able to dislodge the reputation of the Booker Booker.

GP I think it's about setting up a kind of emotional attachment to the significance of the prize, and that is accreted over a period with outrage and discussion, and that forms the mythology of a prize, which is what gives it significance.

LS Yes, the Turner for example is going through this period of transition. It's just been there long enough that now it's an institution, whereas before it got publicity because it was a novelty. Now it's getting publicity because it's tradition.

ML I didn't even understand the Turner Prize qualification rules.

GP I think it's sort of work made in Britain. There is very fluffy wording there.

LS Or like the Whitbread award, where you have to be a resident of Britain for three years.

ML Well, you see, now artists are so rich and jet-setting that it's hard to tell.

GP It is true you've got this cheque and most people who get it probably don't need the money. I also think that when they are choosing who is going to be in the Turner Prize, they consider if it is going to make a good show … And also, we'd better have a woman … I mean, I don't actually know if that goes on, since there was an all-woman shortlist one year, but there have only been three female winners out of twenty-three years.

LS I think the other consideration, and I am torn as to how important this is, but I know that the Orange Prize for example is very involved with libraries and bookshops. In other words, the Orange Prize is very involved in getting their books into the hands of the punters, and therefore there is implicitly an agenda there that you try to select books that are going to appeal to the public. The Booker doesn't have a populist agenda at all.

ML In fact it has the opposite. You are told when you judge it – and of course these terms are very loose and meaningless – that you are looking for a work of serious literary merit. Which is

why I think comic novels have virtually never appeared on the Booker Prize shortlist, because if a book makes them laugh, they think hang on, is this serious literary merit or not?

LS Well, there is a problem with prizes that they don't take this on board. I am not arguing for something that has a common denominator ethos, but at the same time when you do pick an obscure, obtuse, difficult work it's going to alienate people.

ML You are talking about John Banville's *The Sea*, which won the Booker Prize.

LS Precisely. It won the Booker, and the trouble with that in the bigger picture is that the people who go faithfully to the bookstore and buy the latest Booker winner are not necessarily going to like it any better because it won the Booker. And they don't come to the conclusion that the Booker made a mistake this year; they think maybe I don't really like serious literature. When it happens in visual art people think, oh if that's really what contemporary visual art is, well, I guess I just don't like it.

ML That is an important point, because the Turner Prize comes to represent modern art in a way that I don't think is true of any literary prize because there are other books out there. But for a lot of people the Turner Prize is art.

GP It is contemporary art, yes. Alan Bennett said that there should be a sign up outside the National Gallery saying you don't have to like everything, and I think that is something that needs to be rammed home again and again to people. You know, come to the Turner Prize, you might like none of it, you might like all of it. People don't feel qualified to discern because it's an alien language to them. The art world has its own language, and all contemporary art to some extent, even if it's rebelling against it, is addressing the 'lingua franca' of contemporary art. I think you are a fool if you ignore its existence, because it's like someone going to France and shouting in English … You have got to acknowledge that contemporary art has its orthodoxies now. It has its history and it has its way of doing things. You pick up a kind of thought process of people in the art world from living around it for decades, because it's very isolated. It's not like the literary world where you have to take into consideration popularity,

because the people who buy art are insiders on the whole. Most of the collectors want to be part of the difficult – now slightly glamorous – world of art. So in a way it doesn't matter what the public think. They can come along and look at this prize and say, rubbish. The only people who want it to be popular are museums. They want footfall.

ML I think the point about people being embarrassed about not liking it is really important. People occasionally come up to me and whisper they have been to the Velasquez and they didn't think some of them were very good, as if it's some kind of shaming thing, and I said well, that's fine. You are allowed to have that impression. But there is this feeling that you have to like it – particularly if it's been given some kind of prize.

GP Yes, and old masters are old masters because they have been filtered through years and centuries of approval and disapproval and they have survived. You know, they haven't been knocked out in that long-running contest.

LS The tragedy with visual art is people say, oh yuck, I can't stand the entire Turner Prize exhibit, therefore I don't like modern art.

GP Yes, yet if I walk around Frieze Art Fair I only like five per cent of it, probably less, and I don't feel like I'm being disrespectful to contemporary art somehow.

ML You talk about centuries of approval and disapproval that have gone into great works of art. I have this argument with people from the *Mail* and the *Telegraph* all the time, because it seems to me amazing that they don't realise when they say filth in the Turner Prize or whatever, that middle-class favourites, for example, Judi Dench in Chekhov or Ian McKellen in Strindberg, were just as controversial at first. I mean there were literally riots on the first nights of these plays. Ibsen was accused of bringing sewage out of the streets into the theatres. There doesn't seem any acknowledgement of the process that most art is going to be against the middlebrow conventions of the time, if it's going to be any good.

GP Yes, it's a cycle. I mean, we look at the Impressionists now and they are the big coach-party exhibitions. At the time they were throwing a pot in the face of the audience.

ML And Impressionism was an insulting term, wasn't it? It was an insult about what bad taste was going out.

GP Most of the great landmark painters over the last ten centuries have probably at some point been outrageous.

LS The biggest issue probably in visual art now is the challenge to be outrageous. In fact, the Turner last year went into a kind of retreat.

GP I think it was interesting the way that Tomma Abts gave sort of monosyllabic answers to the desperate journos [sic]. When I first saw the exhibition, for me, her paintings were all about what wasn't there. It was like shutting out the clamour of contemporary art.

ML It is self-serving because the media look to be steering the agenda, but then of course they react to it. So what they do is say, 'Yippee, they've listened to us and they've given it to a painter.'

LS I don't think that victoriousness is genuine. I think in fact you deprive the *Daily Telegraph* of what has become a ritual of exercising outrage. It's part of the process. It's part of the theatre.

GP And they are very established traditional roles. I mean you work for a newspaper, so you know that news value is paramount in the way a newspaper is put together. So they are really pissed off if there is not a story.

LS I think the Turner Prize this year was a kind of a non-story.

ML Well, that's why they try to put the twist on it. For ten years running, I had to write the Booker Prize shortlist news story for the *Independent* – news story as opposed to art review. There were only two stories they would accept. One was 'Oh God, it's the same old bores again,' but the other one was 'Who the fuck are they?' and

you weren't allowed anything in between. So you couldn't do 'This is an interesting list selected by...'

GP The media loves the drama of polarisation, so it has two stories. There is not really going to be any graded debate about this.

ML No, but this year I think it was 'shock horror, no shock horror' on the Turner Prize shortlist. But you had the experience of suddenly finding your picture all over the place, which they were able to get hold of easily.

GP Yes, I gave it to them.

ML But was it a shock at the beginning, the level of exposure?

GP Oh no. I had always had – within the art world, certainly – a good relationship with the press. I found it very enjoyable, because I felt very much in control of it. I sat down and I said to the press office here, 'Strap me on, fire the engine, let's go for it. I want to do everything.' For an artist it's a unique opportunity. Normally we live in a sort of cloistered existence in a studio, so suddenly to be offered the chance of rubbing up against the mainstream media – for me anyway – was enormously great fun, and I am quite interested in the phenomenon of celebrity. Now I call myself a celebratty [sic].

ML Obviously Lucian Freud is at the other end of the scale, who just doesn't give any interviews or publicity whatsoever. Did any aspect of it worry you or make you think it might affect your art, [Grayson]?

GP There's a snobbery about publicity within the art world, partly, I think, because it doesn't need the public. I can remember articles dissing people like Anselm Kiefer and Julian Schnabel in the 1980s because they went to nightclubs, on chat shows and they were in fashion shows, and I thought good for them, you know, they've got a bit of action going. It's not for every artist. Some artists of my generation don't want that publicity. Me, I enjoy it. I am a member of the press myself now.

ML You write a column.

GP Yes, I am interested in that kind of modern power I suppose, because I am interested in the sort of workings of the contemporary, the sociology of the arts really.

LS Yet all of the ancillary stuff of writing articles etc. takes time. It's distracting and starts to squeeze out the reason that people are ostensibly artists.

GP I agree with that.

ML Although Grayson was saying he doesn't need the public, as a writer, most of these appearances will sell more books, won't they, [Lionel]?

LS I think I am trying to chart a middle course. For example, I am here today; I am not working right now. Does that matter?

GP You have to be really discerning. I mean, you have to say no a lot. I'm interested in the things that come up when I do things like this. That feeds my work because it's putting me in the kind of national conversation, which I am interested in. When you have won a prize, there is a spotlight on your work, and I get now what I call 'Picasso napkin syndrome', which is that feeling that every bit of stuff I make in the studio has intrinsic value and significance just because I am who I am now. That kind of irks me. In a way I have to be more selective about what goes out of the studio now.

ML The other thing – depending on the work you do, but it would apply to both of you I think – is a lot of interest is in how autobiographical the work is. Unfortunately, that is how people read and react to things, but that's irritating, I assume?

LS It's very irritating. In that sense I do resist celebrity. I find it embarrassing to talk about because I don't think of myself as a celebrity; I am always surprised when somebody recognises me. My experience of it has been distasteful. A good example is when I wore gloves on a *Late Review* programme. A friend of mine recently sent me a blog and their main topic was 'Why does Lionel Shriver

wear gloves?'. A dozen people having this intense conversation. Some of it is really insulting. For example, 'I know for a fact that Lionel Shriver has oversized, red, wrinkly hands with huge knobbly knuckles' [laughter]. In other words, achieving profile by whatever means you achieve it, prizes, publicity, it attracts not only admiration but enmity, and envy and the desire to take you down a peg. Also this impression of imperviousness, that everyone thinks you are so great, so we can say whatever we want about you. We no longer have to concern ourselves with the normal human impulse to consider your feelings.

ML That has become much worse because of the blogosphere [sic]. Thankfully most people are never going to experience what people say behind their backs, but with the blogosphere, it's all there.

LS Retaining a sense of humour about it is the best strategy, and also trying to ignore it as much as possible. Don't go looking for it. But every once in a while someone is going to fashion the bullet to just the right shape.

ML What the media are always doing with people in the public eye is looking for the secret. Now, you may have others, Grayson, but one of your secrets is there. I mean, it's just public.

GP I have sold myself on my secret.

ML And I think that's really fascinating, because whereas the cross-dressers in journalism are desperate for no one to find out, you confuse them because it's just there.

GP Yes, and that was part of the power, if you like, because the papers were put on the back foot. You know, pervert wins Turner Prize, but actually we quite like him. I seem to have this ability to normalise things, particularly sexual matters. People think, what a nice guy whilst I'm thinking, 'Oh damn, I wasn't shocking or controversial.'

ML The question of whether there are too many prizes. I mean, there's a prize for the best second novel and one for best first-time author over sixty and so on. Are there too many?

LS Certainly more than we need. They're not doing anyone any harm though. They probably improve somebody's day [laughs]. They are not going to keep people from buying books, and they're not going to crowd out the prizes that mean something to people. You can bring in a hundred literary prizes and you are still going to have the Booker, the Whitbread or rather the Costa, and the Orange, and that's pretty much it.

GP I think it reflects the size of the market audience. The more people buy books, the more room there is for all the prizes, I think. It would be ridiculous if in ballet, for instance, they had twenty prizes.

ML Another aspect of prizes is the people who run them. In my view they start over-milking them, so you have this thing of the longlist now. I mean, when the Booker Prize started, there were four on a shortlist and now it's a longlist of twenty. I saw a book the other day that said 'nominated for the Booker Prize', which simply meant entered by the publisher. Publishers like the longlist because it's more publicity for more books, but I feel that the authority of the prize is reduced if you have so many books in public contention.

LS Yes, you water it down a little bit. I think they are trying to set up a sense of tension and more moments in the year when you have the prize being at issue. Again, I don't think it does a lot of harm. The public is only going to pay attention at discrete points, and you are not going to force them to pay more attention because they don't care enough.

ML The only issue there, I think, it's a small point but it sometimes worries me, is I think the longlist comes out in August and there are books that haven't been published yet on it. You have this weird spectacle of books that are seen to have failed before they are even published because they didn't make the longlist.

LS Let's not forget that there is an element of the arbitrary in the selection all along the way. There is a lot of injustice. I certainly know what it's like for most of my career to be left off every list in the world because my publisher wasn't socialising with the right people or the book wasn't well timed, or whatever people tell themselves who weren't on the list. Maybe they just all sucked

[laughter] ... But in any event there are a lot of people left out of the process, and therefore their hopes are dashed, sometimes their fortunes are going to be reduced by being left out or being conspicuously left out, and it creates some real bitterness within artistic communities. I mean the person who wins doesn't end up being best friends with the people who have lost. I can testify to that [laughter].

ML But I think it's the economics though, isn't it, because I suspect from what I know that you can make a more than decent living in the art world without ever being shortlisted for the Turner Prize, whereas in literature it is harder.

GP Is there a history in, say, the Booker or the Orange Prize of people turning down nominations? I doubt there is.

ML John le Carré refuses to be entered for prizes, actually, for all the things we've been talking about; he thinks it's arbitrary and unfair. More interestingly, he thinks that he doesn't need it, that it would be better for it to go to lesser-known authors...

LS Well, that is reasoning I respect. Too often for my taste in America prizes go to the most obvious candidate who doesn't need the elevation, and is going to get the sales anyway.

ML Do you think there is that kind of bitterness in the art world, [Grayson]?

GP I mean, it's going to be a challenged relationship with someone that you are up against. I was well post-therapy so I could deal with it [laughter]. I speak to all of the people I have met since who were up against me, and it seems fine. What they say in private, I don't know.

ML But is there a clear dividing line between people who are shortlisted or have won the Turner Prize and people who haven't ever got there, in the art world?

GP In terms of name-checkability [sic], probably. It's very hard to judge how well known one is. I'm lucky, I can leave my fame in the wardrobe to a certain extent, but when I'm dressed up

quite a few people know who I am, so it's fine. But whether that would have happened eventually without the Turner Prize I doubt.

ML It will be interesting to see what happens to Tomma Abts, because it looks as though she is going the opposite line from you. It doesn't seem as if she is going to write newspaper columns and appear in public at all.

GP Fame is interesting in the art world in that it affects not just the artists, but it can affect the gallery and it can affect the collector. I think it's very important to certain kinds of collectors to say 'I have a Tomma Abts on the wall', because of the status that is attached to that.

ML We haven't thought about the emotional bit of it. Let's go back to the moment when you discovered you'd won the Turner Prize. Was it a moment of great internal joy?

GP I was shocked because on the evening of the prize, my wife and I were trying to suss out the judges at this cocktail party before the dinner. We were trying to read their minds and their body language. Victoria Miro was next to me at the dinner, and she leant over and said 'Oh Grayson, I don't think you've won, I think Willie Doherty has won.' She said it with such conviction, I thought she must have heard. This was about two minutes before the announcements, and of course the cameras were all pointing at the Chapman Brothers, but then they all swivelled round to me at the last moment.

ML People always say with a jury that if they won't look you in the eye when they come back in, they've found you guilty. So when I judged the Booker, we deliberately didn't look any of the authors in the eye, so they were all convinced that they had lost. But going back, your moment?

LS I had a different experience with the preliminaries. Jenny Murray, who was chairing the panel, wanted to make sure that my publishers were taking me out to a nice dinner afterwards, knowing perfectly well that I would have been briefed that if you win, you don't end up eating anything, because you are swept away to this little room. So what it seemed she was doing was letting me know ahead of time that I wasn't going to win.

ML So you assumed you hadn't won, then?

LS I wasn't quite sure how to interpret it because she does have a mischievous side, so she was either deliberately misleading me or indeed trying to let me down gently. I figured the chances were about fifty-fifty. In the lead-up to that event, I discovered – and I can only speak for myself, but it may be universal – that you immediately start trying to protect yourself from thinking that you are going to win … Yet if you are up for something that pays and will make a big difference in your life, then you can't make yourself not want it, and therefore you cannot protect yourself from disappointment if you don't get it. So, coming up to a couple of weeks before it I just stopped trying to tell myself I wasn't going to win and sat around hoping that I would. That's all I could do. It was at least being honest with myself. So, when I went to the event, I had prepared an acceptance speech.

ML I wanted to ask about that, because it's great at the Oscars when people say, this is a complete utter shock, and then pull out a four-page typed speech that they've had ready. But you had prepared one?

LS We were told we should be preparing, and I took that seriously. I had forty-five minutes before I had to start getting ready, and sat down at the computer and made a few notes. I knew that even the sheer physicality of the printout in my handbag if I didn't win would torture me later.

ML I was just thinking of what used to happen in newspapers. In the days when it was hard to typeset a page, they used to do both front pages, one for the winner and one for the loser, and then if you were the loser, which must have been unbearable, they gave you the front page. Did you have your speech ready?

GP Oh yes. I did a short and sweet one because I knew I wouldn't have long, but I had honed it down to a very few lines. I was really pleased with it actually. Of course I'd prepared a dress for the occasion as well, which paid off enormously, except now I call it my Liz Hurley dress in that I can't really wear it anywhere else.

LS I just thought the whole thing was really interesting. I found it internally interesting. I liked watching myself, seeing how

I dealt with it. I enjoyed watching the way the other candidates for the prize interacted … It was emotionally interesting, and I think that would have been true even if I lost. For me in that moment when it was announced, I experienced one of those rare instants of being fully present, in contrast to the normal-life experience of not being quite in the moment, always being slightly to the side thinking ahead or thinking back.

GP And talking of time, the one thing about prizes, they are a news story that is happening now, they are very current, but tomorrow they will be old news. So they focus on the present very much, which is a good thing about them, I think.

LS And in terms of my experience of that moment, that's what I loved about it. It happened perfectly. It's like the perfect geometric point.

ML A good thing to close on, I think, because this book is looking back on the effect of the Turner Prize, is to talk about counter-histories. If the Turner Prize hadn't been set up, I mean, obviously it would be different for you, [Grayson], but how different would the entire art scene be?

GP I think it wouldn't have so much interaction with the mainstream. In the newspapers now there's a story about contemporary art pretty much every day, and I don't think that was there twenty-five years ago. Perhaps London would still be the capital of the art world, as it is now, but I think the public wouldn't have been brought along for the ride.

ML The Orange Prize, any of them – if we imagine a literary world in Britain without prizes, the sales would be vastly lower, wouldn't they, [Lionel]?

LS I think so.

ML If you could win another prize, what would it be?

GP The Lion D'Or at the Venice Film Festival, that would be a good one.

ML And for you, [Lionel]?

LS I would love to win the Booker and change the rules.
But I think I could stick the National Book Award in the States.

GP I'm going for columnist of the year this year.
[ML laughs]

ML That's great, thank you very much.

LS Thank you.

Grayson Perry accepting the 2003 Turner Prize from Peter Blake

Lionel Shriver, winner 2005 Orange Prize for Fiction

MARTIN CREED

1968 Born Wakefield, England
1986–90 Slade School of Fine Art, London

Lives and works in London

Won 2001

I grew up with the Turner Prize. When I was at art school, the prize was just getting big and I used to watch it on TV. I was into it. I wanted to win it! It was exciting to be asked to be in it, but it was scary. It was a bigger, more public stage than I'd worked on before, with a bigger audience. I didn't want to fall over. It made me think: what do I really want to stand next to and be judged on? It made me think again about my work.

When the Turner Prize first started, it was like an award for lifetime achievement, for work that had already been established, whereas now it seems a bit more like an award for rather younger artists. Now it could be someone's first show in a big museum.

I think the Turner Prize has had a massive impact on contemporary art. It is famous worldwide; it has an enormous audience; it's great. The difficulty of being involved in it for me was realising that I desperately wanted to win it. That made me feel quite vulnerable.

When I was asked, I was given a chance to think about it, but I had no doubt that I wanted to be part of it. It was just the fear of not winning - of losing - that was the only problem. I told myself: 'But it's just a stupid prize; just the judges' personal opinions,' but I couldn't stop caring about it. An exhibition is like a demand, a plea for attention. Artists compete for attention, trying in their own way to win love. But failure can be avoided, because each artist makes their own rules and runs their own race; it's a field without a finishing line in which everyone can kid themselves a little bit. The Turner Prize draws a finishing line, makes a brutal competitive situation, treats art more like sport and brings it out of its shell. It is enjoyable to watch and exciting to be part of.

From an interview with Martin Creed by Katharine Stout, 2007

GRENVILLE DAVEY

1961	Born Launceston, Cornwall
1981-2	Exeter College of Art
1982-5	Goldsmiths College, London

Lives and works in Essex

Won 1992

The Turner Prize just happened for me. I'd just had a big show at the Chisenhale Gallery which I was really happy with, so it felt like the work was in the right place. You just have to go into it without thinking about whether you're going to win it.

I was really pleased to be nominated with the other artists that year, and that was an antidote to any pressure during the exhibition. In the end you don't have to take part.

What happens afterwards is down to the individual. I haven't had shows for a long time, as I've been doing other things I wanted to do. I was really happy with the work at the time of the Turner Prize, and afterwards it just got very noisy, since lots of people had things to say about it. I met so many people who were positive about the work, and quite often they were complete strangers.

I think the relationship between television, the artists and their work is really awkward – that was the main problem I had. The problem is reducing it to the lowest level of television entertainment.

The criticisms in the press were quite tongue-in-cheek, being an outsider, etc., and that's about as bad as it got, really. Much as some people really enjoy the Turner Prize, others really object to it, which I suppose makes the artists involved a target. It's better now that the shortlisted artists get some money as well. I think there was a period in the mid-1990s when the money became too much of an issue.

You don't take much notice of bad press, and the good press generally outweighs the bad.

What's amazing is that it's such a long time ago, over fourteen years, and yet it's still mentioned to me all the time. It's a double-edged sword, because it can count against you as well, but I got over that by going in another direction.

The really positive side of the Turner Prize is that the public who come to see the exhibition really enjoy it, or hate it.

From an interview with Grenville Davey by Katharine Stout, 2007

RICHARD DEACON

1949	Born Bangor
1969-72	St Martin's School of Art, London
1974-7	MA, Environmental Media, Royal College of Art, London
1991-6	Trustee of the Tate Gallery

Lives and works in London

Shortlisted 1984, Won 1987

The only way to make the Turner Prize work was to make it a media event. The Booker Prize was a model, as it was so effective. However, with the Booker Prize everyone gets to read the books. With the Turner Prize, the public is constantly under the impression that what's in the exhibition is what's being judged. There is always a slight dichotomy between wanting to engage the public and the fact that the body of work that justified the inclusion of the artist on the shortlist was sometimes only accessible to a very small number of people.

The films do a good job of contextualising an artist's practice. In 1984 it was all down to punditry and advocacy, really. The interest was generated through print journalism. I found the experience very unpleasant the first time. Clearly I was nominated as the outsider, as I had done very little: I was chosen on potential rather than actual achievement. I found it destructive, because it made me think about reputation in ways I didn't like. Alongside artists such as Malcolm Morley, Howard Hodgkin and Gilbert and George, there was no way I was going to win, but then you somehow think, well, maybe you might. It sets up an expectation which I didn't like. It causes confusion in your head if it comes too early. But you have to be very tough to say no and not regret it afterwards.

In 1987 it was a different ballgame in terms of the level of my practice and the extent of my exposure. And it did make a difference to collector interest and my market position. So the prize had been successfully promoted within that very short period as being something important. The status of British art in general had also heated up. Nothing like what happened in the mid-1990s, but it was certainly the first wave of fashion attention to the British art scene. I was the first of a slightly younger generation to win it, and I got a lot of support from artists at the time. I was actually fairly convinced I was going to win, as I realised I had quite a good chance. So it felt very good.

I think Channel 4 had a very clear idea of what to do with the prize when they took it on in 1991. It already had some pedigree attached to it, and a good list of artist winners with some controversy around it. But Channel 4 got a format that worked, and through the 1990s it did work very well. It chimed with artists' ambitions at the time. Most artists are fairly canny about celebrity. Either they're willing to exploit it or they want to refuse it. Being an artist is never like being a pop star. There is much more privacy than publicity.

For an artist now, either as someone shortlisted or someone who wins the Turner Prize, you join a large group of people whom you respect – it's an outstanding list. Whether it still has as strong a role to play in promoting contemporary art is more difficult to answer. The media interest attracts a large group of people and so serves a positive function. And that's down to the Tate continuing to back it up with the resources of a big show and a media blitz. Artists will always respond to that opportunity. The problem is really to do with the Tate maintaining sufficient interest, given the number of times that art now crosses over into the news pages. That's a lot to do with the Turner Prize. Personality becomes more of an issue than it should. The existence of the artists' television profiles is a really important element. It's a key link that needs to be maintained in such a way that the artists think of it as a great opportunity rather than something that demeans them.

From an interview with Richard Deacon by Lizzie Carey-Thomas, 2007

JEREMY DELLER

1966 Born London
1985–8 Courtauld Institute of Art, London

Lives and works in London

Won 2004

One of the reasons I took part in the Turner Prize was to see what it was like to go through the process, as a social experiment. Everyone has an opinion about it, but very few people get to be part of it. If I hadn't said yes I'd definitely have regretted it, because I'd still be wondering what it was like. I was curious, nosy really, to see what the process was like. And I really enjoyed it. Getting people into the room, doing little tours for people – I didn't mind that at all. And the fact that a lot of people saw the show was really overwhelming. I was interested in the audience and what they'd make of it, and I was shocked at how many people came and how intensely engaged they were. I was totally blown away by that. If I'd lost I would be less positive. But it was a nice moment, a good couple of months. My parents were happy, my friends were happy. You can use all that energy that the prize has around it and channel it in your direction, siphon it off. I was definitely looking for some sort of conversation, some sort of feedback.

I was very lucky critically. I was expecting to be criticised just for being in the show. Certainly the press were very gentle to me and no-one seemed aggressive towards me personally. I was lucky to have both the popular audience and the art audience. I think it was strategically the right time to show work like mine, and I found the

public side of things fine. The Tate press office helps keep you at a distance from all that.

Since winning the prize it's been easier to get hold of people, to do things, so it's a very good calling-card in that respect. It means I can do things I wouldn't have been able to do otherwise, and so far it's only helped me. People are interested in meeting you because you won it. It says a lot about the public's acceptance of British art that it means something to put 'Turner Prize' in front of your name. The general public are really interested in art and artists, and always have been.

The prize is heavily geared towards the press, they're very important in the whole process. It might be an idea to change that. People say it should take place every other year, and I don't think that's a terrible idea. It could travel beyond London. It's great that it will be in Liverpool this year. Maybe it should go to other places too. And the age limit could be removed. If anything, it's the older artists who don't get enough attention, the younger ones who get too much. In a way the Turner Prize is responsible for that, a victim of its own success. Younger artists would love to show with older artists, rather than everyone they've hung out with for the last ten years.

Most people get their view of the prize through the press and television, but still only a minority actually go to see it. I think the press really shape it. Everyone seems to cover it. But even serious art critics feel they have to make some sort of judgement. It's human nature: we're competitive, and prizes can bring out the worst in people.

I think the role of the prize has probably decreased. People take notice of contemporary art now anyway; there are enough art galleries and exhibitions and art fairs that fulfil that role. But the Turner Prize is still the one contemporary art exhibition that people will make a point of seeing. If it gives the Tate an international profile, then that's probably the most important thing now that museums are increasingly developing world-wide strategies. Tate Modern is one concrete building, you know what you're looking at, but with the Turner Prize there's no one image in your mind. It's an idea rather than a thing. I always recommend the Turner Prize to artists as a good thing to do. But it's not for the faint-hearted.

From an interview with Jeremy Deller by Lizzie Carey-Thomas, 2007

ANYA GALLACCIO

1963 Born Glasgow, Scotland
1984-5 Kingston Polytechnic
1985-8 Goldsmiths College, London

Lives and works in London

Shortlisted 2003

By the time I was nominated I had supported a number of close friends through the Turner Prize, both winners and losers, and seen at first hand how they were affected both during the run up to the show and afterwards. So, I was nervous about some things and determined not to be emotionally derailed. It seemed to be an opportunity to present work to a larger audience, rather than the moment to make a new statement, or to challenge those expectations.

Whilst I felt that I was being supported, it wasn't a very challenging or exciting show to do. I suppose it is also pretty weird participating in a group show where you are kept away from the other artists. One of the things I enjoy about being in a group situation is the interaction with the other artists, seeing how other people work, making some kind of connection. Support from one's peers is something I value greatly.

I wouldn't deny that I am ambitious, but I rarely put myself knowingly into situations where the objective is 'to compete'. Art is a subjective endeavour both in its practice and its appreciation. It is a gamble accepting the nomination, as you can only speculate on the rest of the list. I was really pleased when I found out who I was up against. I never thought that I had a chance to win, but I wanted to be 'beaten' by someone I respected. So I felt relatively comfortable going into it. But I had some unspecific sublimated desire for 'something' to come out of it.

I was clear about all the 'negative' implications of being involved, from watching before, but I had no clear 'positive' objectives. I didn't think about the possibility of winning, but I did have an expectation that 'something' would be different afterwards. I guess the hardest thing about the whole experience is that nothing changes; you don't feel any different, and no one treats you any differently. I went into it with this sense of dread and caution, then the sky didn't fall in and the sun kept shining.

I don't think that the Turner Prize makes as much difference to artists anymore. The artists who are nominated have generally reached a high level of visibility internationally. I can remember the excitement when the prize was re-launched in the early 1990s and Damien Hirst, Rachel Whiteread, Fiona Rae and Ian Davenport were nominated. It seemed a serious validation to be included. I think for a younger generation of emerging artists it is hard to imagine the situation then. It is very much a reality now to go into art education with the idea of having some concrete success at the end of it.

The prize has had a huge impact on public perceptions of contemporary art. It seems to be very little to do with celebrating the specifics of the actual artists participating each year, who at times almost seem to be cyphers 'representing' positions or possibilities and bringing these into a mainstream public conversation. This has been great for cranking up the machine that is the 'art industry'. Look at how many column inches are now given over to art events and individuals, the huge increase of galleries and exhibitions all over the UK, the boom in art related courses, from practice to curating and of course the existence of Tate Modern.

While one role of the Tate is to promote and extend its audiences, this should not be done at any cost. Surely behind this agenda should be some 'higher' goal, a belief in 'art', which is not all easily digestible, accessible and marketable. The Turner Prize has spent 20 years preparing the way and now there is a high chance that someone on the street could name a living British artist. So it is time to find a way to establish some kind of new venture that genuinely acknowledges achievement. Or to launch a commissioning prize to give artists something to get their teeth stuck into. There are loads of great artists here, doing interesting and challenging work, but Tate needs to come up with a new forum to celebrate or champion the success of Britain within the international arena.

From an interview with Anya Gallaccio by Lizzie Carey-Thomas, 2007

VONG PHAOPHANIT

1961 Born Laos
1980-5 Ecole des Beaux-arts, Aix-en-Provence
1985 Moves to Britain

Lives and works in London

Shortlisted 1993

Participating in the Turner Prize was the first time I experienced such wide exposure: before that my practice was much quieter. I had only been in the country for eight years – I arrived in 1985 and was nominated in 1993 – so it happened very fast. And it was a great opportunity to show the work. I was pleased for those around me who had supported the work: family, friends and curators. However, you keep asking yourself why you've been nominated. It takes some time to digest. All I could do at that time was preserve my integrity and above all concentrate on making work and continuing my practice without becoming too caught up it all that surrounds the prize.

I don't think it had an effect on the work I made afterwards, because the work I showed, *Neon Rice Field*, had already been developed two or three years prior to the Turner Prize, so my work had already moved on. The work is the work; all the questions of how you relate to it and how the work changes are usually more to do with life. The Turner Prize may allow you more opportunities to realise new works, or facilitate them, though it's hard to say how much.

I think it is hard for young artists to deal with the media aspect – for me it happened fourteen years ago, so I am now more distanced from it. They have to be prepared and protected by the

Tate and their supporters. But artists will never be prepared enough, because the press and television have different rules and agendas. It's a kind of contract you get into. In the end, it's up to the individual to deal with it. There is the obvious debate that goes on every year - is it art or is it not art? - and that will go on forever, but one has to look beyond that, because usually that kind of discussion doesn't go anywhere. It's always difficult to raise the level of the debate when you're dealing with the tabloid press, but ultimately, people make their own judgments. I personally always respect the viewers: even if it doesn't make much sense to people at the time, maybe in five, ten years, something of the work will come back to them, and they will make sense of it. The fact that debate happens keeps it current and injects energy into contemporary art practice. It's not just to do with art, but also with identity and culture, so it touches many levels in our lives, and in that sense is important. If you took the Turner Prize away, it would be replaced by something else, so the need is there. Every year raises new questions and new debate, depending on the nominees. The year of my nomination there was a big discussion about whether a 'foreign' artist could take part in Turner Prize. Actually I was granted British nationality while I was a nominee, so the two things happened at the same time for me, which was very interesting in itself but not something I chose to discuss in the public arena at the time. It seemed to be the first time these issues were raised and discussed, and I think Tate had to clarify its position after that.

I believe that the Turner Prize should continue: it is a platform for debate and it promotes liberty of expression - and this is of key importance, particularly at the moment. Turner Prize prepared people for Tate Modern - there's no doubt about that, it was almost one of the first bricks. That's why I still think it's important. It's up to the judges, the Tate and the media, to keep it challenging and interesting. Turner Prize is important for curators, for art critics, as an annual event to gauge what is happening at that moment. It is now commonly accepted that there is a thirst for contemporary art in our culture, and the Turner Prize has undoubtedly played a role in that.

From an interview with Vong Phaophanit by Katharine Stout, 2007

JANE AND LOUISE WILSON

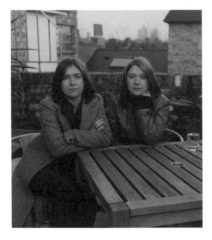

Jane Wilson
1967 Born Newcastle-upon-Tyne
1986-9 Newcastle Polytechnic
1990-2 Goldsmiths College, London

Lives and works in London

Louise Wilson
1967 Born Newcastle-upon-Tyne
1986-9 Duncan of Jordanstone
 College of Art, Dundee
1990-2 Goldsmiths College, London

Lives and works in London

Shortlisted 1999

The nomination for the Turner Prize was the culmination of a really great year for us. It was the year we made our first two person exhibition at the Lisson Gallery, where we showed *Gamma* (1999), for which we were nominated. We were then invited to do our first two person museum show at the Serpentine Gallery that same year. It was an incredibly busy and productive time for us and the Turner Prize gave us an opportunity to show a new work, *Las Vegas, Graveyard Time* (1999).

For us, participating didn't mean that we had to suffer any of that boring interiority that can come with sudden affirmation. If anything, it propelled us to go further, in that you gain all of the exposure with none of the pressure.

Because of the momentum and interest surrounding the prize it meant that our work was seen by a much wider audience. This is what makes it so unique, the work is propelled from an intentional audience to an incidental one. It was a great boost to us and our work which meant that the following year we could hit the ground running. *From an interview with Jane and Louise Wilson by Katharine Stout, 2007*

TOMORROW NEVER KNOWS

TOM MORTON

'How would you like it if we tried to compose a history?'
'I would like nothing better. But which?'
'Indeed, which?'
Gustave Flaubert, *Bouvard and Pécuchet* (1881)

Asked to describe the impact of the French Revolution, Zhou Enlai, the first Premier of the People's Republic of China, is reported to have replied, 'It's too early to tell.' Whatever the veracity of this celebrated *bon mot* (and it is very probably apocryphal), it speaks of a certain truth. To compose a history is a difficult business, especially one of a period that is temporally close at hand. To compose one on the basis of evidence that you know to be incomplete, and burnished by multiple biases, is little more than intellectual folly. It follows that the history of the Academy Awards is not the history of American cinema, that the history of Crufts is not the history of British dog-breeding, and that the history of the Turner Prize is not the history of recent British art.

Since its inception in 1984, some ninety-one individuals (most, but not all of them, artists) have been shortlisted for the Turner Prize. Of these, twenty-two have been named as the winner; as the person who, with various caveats and codicils, made the most important contribution to British art during a particular twelve-month period. Making such decisions is, of course, problematic. No prize jury, however sensitive, knowledgeable or well-marshalled its members, will always draw up a universally satisfying shortlist, and nor will they always pick the most deserving winner. Sins of under- and over-valuation are inevitable, as are those of omission. Add to this the fact that shortlists are composed, necessarily, only of those who have accepted the invitation to feature on them, and the wisdom of the late critic Stuart Morgan's maxim that: 'Art is not a competition. Artists are not in competition with each other but with themselves and the past,'[1] becomes evident. It is clear that any cultural award, from the Nobel Prize for Literature to Pop Idol to the Turner itself, is at best a deeply compromised indicator of what, at a given moment, is vital in a given field. What twenty-two years of Turner Prize shortlists *does* yield, however, is a history of attention, of looking at and thinking about and feeling the subtle or brutal force of the work of nearly a hundred artists who have, in their very different ways, shaped British art since the mid-1980s.

The past is a foreign country, but it is not an alien world. Looking back at the artists shortlisted for the Turner Prize prior to

John Walker *Form and Sepik Mask* 1984
Oil on canvas, 243.8 x 152, courtesy the artist

Stephen McKenna *Clio Observing the Fifth Style* 1985
Oil on canvas, 200 x 280, Private collection

its temporary suspension in 1990, one finds, if not quite a *Who's Who* of those we might now regard as the most high-profile British artists working during that period, then at least a desiccated *Debrett's*. Gilbert and George figure, as do Lucian Freud, Howard Hodgkin, Patrick Caulfield, Paula Rego, Helen Chadwick, Malcolm Morley, Richard Hamilton and Richard Long – names that will be familiar today to anybody who frequents major art museums, or even flicks idly through the arts pages of the broadsheet newspapers. While it would be superfluous, here, to recount their achievements in any detail, it's perhaps worth taking a backwards glance at the work of other shortlisted artists from this time who have faded a little from our collective cultural memory. Take John Walker, nominated for the prize in 1985, on the right of whose painting *Form and Sepik Mask* (1984) stands a vast, Oceanic mask, its angular face in profile, its coppery surface alive with flaming light, or else blackened by invisible fires. On the left, beneath squally, smoking skies, sits what might be a human figure, its legs crossed in meditation, its face turned not outwards to a changing world, but towards the mask, with its suspicious guarantees of universalism, of immutable value. A similar orientation exists in the canvases of Stephen McKenna, nominated for the prize in 1986, whose *Clio Observing the Fifth Style* (1985) is overloaded with such an abundance of allegorical figures and art-historical allusions that it's hard not to interpret it as a desperate attempt to plug painting back into the Western tradition. (While it's possible to read McKenna's work in the spirit of mock-heroic playfulness, his statement that: 'If one sees our Western culture as a body of works, rather than as a progression of ideas determined by some inscrutable historian, it becomes unnecessary to worry about one's distance from the last temporal marker,' seems to indicate the contrary). To locate these works in a wider (art) historical context, one might point – especially in Walker's case – not only to the work of contemporaneous British Neo-Expressionists such as Christopher Le Brun, whose mythical subject matter echoed the early 1980s' revival of interest in the kind of essentialist comparative anthropology espoused in Joseph Campbell's book *The Hero With a Thousand Faces* (1949), but also to German *Neue Wilden* artists such as Georg Baselitz and Anselm Keifer, who first came to wider British attention in the Royal Academy of Art's 1981 exhibition *A New Spirit in Painting*, having the year before been accused of being ideologically and aesthetically reactionary on the basis of their two-person show at the Venice Biennale's German Pavilion. Combining a certain enduring strain

of Jungian thought with the turn away from 1970s' Minimalism and Conceptualism that *A New Spirit* (which also featured the work of American Neo-Expressionist Julian Schnabel) showcased, the paintings of Walker and McKenna are examples of the type of culturally conservative postmodernism that would give rise to everything from the utopian 'new village' of Poundsbury, Dorset, designed in the late 1980s to reflect Prince Charles' beliefs about architecture, to Robert Bly's *Iron John* (1990), the founding text of the early 1990s' 'Mythopoetic Men's Movement'.

Against the background of Walker and McKenna's mid-1980s Turner nominations, it's perhaps interesting to note that of the artist, poet, theatre designer and filmmaker Derek Jarman, who was shortlisted in 1986 for his feature film *Caravaggio* (1986). In this not-quite-biopic of the seventeenth-century Baroque painter, Jarman made gleeful use of anachronism (Roman merchants wield pocket calculators, bars are illuminated by strip-lights, scribes tap away at typewriters) to flag up Caravaggio's contemporaneity, from the temporal transvesticism of the saints and sinners on his canvases, to his unabashed depictions of homosexual desire, to his pioneering use of dramatic, sharply contrasting darks and lights, a painterly device that might be said to have prefigured and perhaps even influenced twentieth-century cinematography.

The early years of the Turner Prize contain, then, not only an incomplete roll-call of the high priesthood of postwar British Art (notable absences include David Hockney, Peter Blake, Michael Andrews, Anthony Caro, Philip King, and Eduardo Paolozzi among others – pointing, if nothing else, towards a possible desire to periodise these still active practitioners as exponents of 1960s' Pop or 'New Generation' sculpture), but also a struggle over how the mythic and the classical might be employed by artists towards the end of the second millennium. Is the past a song line, a retreat, or else an antechamber of the future?

Following its suspension in 1990, the Turner was reintroduced in 1991 with a new upper age limit of fifty for shortlisted artists, implemented to prevent the prize from ossifying into a lifetime-achievement award. One result of this was a gradual shift in focus towards a new generation of artists that are now commonly described as the YBAs (Young British Artists), or grouped rather problematically under the umbrella of 'Britart' – a term that seems intimately tied to a certain rather provincial post-recession national confidence in everything from pop music to the Clintonian re-imagining of the

Dir. Derek Jarman *Caravaggio* 1986

Labour Party that followed its defeat in the 1992 General Election.
Again, it is unnecessary to map this phenomenon here, but it might
just be worth remarking on how such labels peel and wear thin when
they are subjected to visual scrutiny. While, say, 1993 winner Rachel
Whiteread's *House* (1993), 1995 winner Damien Hirst's *Mother and
Child Divided* (1993), and 1999 nominee Tracey Emin's *My Bed* (1999)
all deal with material arrest and decay, they are strikingly different
in the ways in which they engage (or not) with a whole parcel of
other issues, among them memory, community, the corporeal, the
abject, the autobiographical, and the hand of art history. What such
terminology occludes, then, is a plurality of approach in post-1980s
British art that ultimately resists categorisation. No responsible art
historian would ignore the significance of the fact that many of the
artists identified as YBAs studied at the same set of London art schools,
showed in the same set of seminal group exhibitions, worked with
the same set of commercial galleries and inhabited the same social
scene, but neither would they deny that the best of them achieved
something much richer and stranger than membership of a (partly
media-created) club. What connects, say, 1994 prize nominee Peter
Doig's painting *Cabin Essence* (1993-4) – in which Le Corbusier's
Modernist apartment block the *Unité d'Habitation* is glimpsed through
a tangle of nightmarish, very Edvard Munch-like trees – and 1997
Winner Gillian Wearing's video *Dancing in Peckham* (1994) – in which
the artist performs an ecstatic dance in a shopping mall to the music
of her mind – is not a shared manifesto, or even a shared aesthetic,
but rather an understanding that sometimes we need to be unsettled
if we are to wake up and see the world anew.

Glance at the work of the artists nominated for the prize
since 1984, and the most surprising commonalities are thrown up.
We might imagine 1993 nominee Vong Phaophanit's site-specific
piece *Litterae Lucentes* (*Words of Light*, 1993) – in which the Laos-born
artist placed nine, untranslated Laotian words fashioned in red
neon on the kitchen garden wall of an eighteenth-century National
Trust property – as an unexpected descendant of 1985 nominee Ian
Hamilton Finlay's extraordinary *Little Sparta* (1967-2006), a
'philosophical garden' in the grounds of the artist's Dunsyre home,
in which sculpture and engraved passages of poetry combined with
plants, rocks and water features to explore the persistence and
mutability of ideas, language and form. Equally, looking at the work
of 1984 winner Malcolm Morley, 1991 nominee Fiona Rae, and 2000
nominee Glenn Brown, the three artists seem to share a concern

Vong Phaophanit *Neon Rice Field* 1993
Neon and rice, 1500 x 500, Collection Weltkunst Foundation, Irish Museum of Modern Art

Glenn Brown *The Tragic Conversion of Salvador Dali (after John Martin)* 1998
Oil on canvas, 222 x 323, Private collection

Michael Raedecker *Echo* 2000
Oil, acrylic and thread on canvas, 254 x 198, courtesy the artist and The Approach, London

Gillian Carnegie *Fleurs de Huile* 2001
Oil on board, 88 x 47, courtesy the artist and Cabinet Gallery, London

with the notion (present in the canvases of the 1980s Neo-Expressionists) of painterly 'genius' by employing a magpie approach to the styles and motifs of the art of the past, which in their very different ways they then montage, remix and transform into something new.

Other commonalities in the work of shortlisted artists are more atmospheric – think of the combination of entropic delicacy and subdued, sinewy kinkiness present in the art of 2000 nominee Michael Raedecker, 2005 nominee Gillian Carnegie and 2006 nominee Rebecca Warren – or turn on the use of similar forms to similar ends – think of the sweet, deadly and decidedly narcotic consumerist release promised by 1995 winner Damien Hirst's spot painting *Amodiaquin* (1993), which is also offered up by the dappled hides of the ceramic pedigree dogs in 1988 nominee David Mach's installation *101 Dalmatians* (1988). But whatever the nature of the connecting lines we might draw between one Turner Prize contender and another, it is significant that they often traverse mediums, generations and cultural moments. If the history of the prize teaches us anything, surely it is that British art of the last quarter-century does not conform to a Vasarian – which is to say crudely evolutionary – temporal model. Many of the shortlisted artists are time travellers – inhabitants of today, yes, but of yesterday and tomorrow, too.

To think about what the history of the Turner prize tells us about the history of recent British art is to do so in a particular time and place. Right now, we might value certain of the traces of artistic activity it speaks of quite differently from the audiences of the future – it's worth remembering that Caravaggio, the subject of Jarman's film, endured a long period of critical invisibility before his rediscovery in the twentieth century. It is very possible that tomorrow's commentators will criticise the paucity of female nominees and winners (to date only thirty-one women have been shortlisted, and only three have won the prize). So, too, might they criticise its rather late recognition of 2002 nominee Liam Gillick, who in the 1990s became, alongside international artists such as Carsten Höller, Pierre Huyghe, Philippe Parreno and Rirkrit Tiravanija, a key figure in the creation of the set of radically de-centred, often participatory practices that are now commonly, and perhaps unhelpfully, known as 'relational art', and which, if current scholarly attention is any indicator, may well come to be regarded by future art audiences as the most significant development of that decade. (While Hal Foster, Rosalind Krauss, Yve-Alain Bois and Benjamin Buchloh's magisterial 2005 survey

Liam Gillick *Coats of Asbestos Spangled with Mica* 2002
Anodised aluminium and perspex, 840 x 1680, courtesy the artist and Corvi Mora, London

Jeremy Deller *The Battle of Orgreave* 2001
Comissioned and produced by Artangel

book *Art Since 1900* devotes much space to this trend, 'Britart' is presented as, at best, an art-historical footnote.) Gillick's absence from the shortlist during the 1990s might be put down to the fact that the overwhelming majority of his projects took place outside Britain, but geographical distance cannot account for the fact that the prize's jurors failed, in the early years of this century, even to shortlist Jeremy Deller for his *Battle of Orgreave* (2001), a project in which the artist worked with residents of a Yorkshire pit village (many of them ex-pickets) to restage one of the bloodiest battles of the 1984–5 miners' strike, and which is now beginning to be recognised as one of the most important works of British art of recent years. Deller was later awarded the prize in 2004 for his Americana-tinged project *Memory Bucket* (2003), but it's hard to shake the feeling that that year's jurors were, in part, rectifying their predecessors' oversight.

Recent years have seen the Turner Prize be awarded to a number of artists whose future reputations now feel assured. Given their post-prize participation in numerous major exhibitions and biennials, the acquisition of their works by major museums, and the sheer volume of critical commentary on their practices, it's hard to imagine, say, 1996 winner Douglas Gordon, 1999 winner Steve McQueen, 2000 winner Wolfgang Tillmans, or 2001 winner Martin Creed slipping from view. This is not to say that cultural awards guarantee lasting attention (who now reads the novels of inaugural Booker Prize winner P.H. Newby?), but they may at times point to something of potentially lasting value, whether that be Gordon's subversion of the rhetoric of the moving image, McQueen's meditations on memory, power and resistance, Tillman's hopeful, poetic chronicling of the everyday, or Creed's funny, anguished and very precise reckoning with the ethics of introducing yet another object into an already overcrowded world. In the final analysis, though, such prophesying is necessarily provisional, and only a little more than a rarified parlour game. The value of the prize is not in its doubtful ability to build a canon, but rather in the grubby, broken mirror it holds up to British art now, and the wide audience that peers therein.

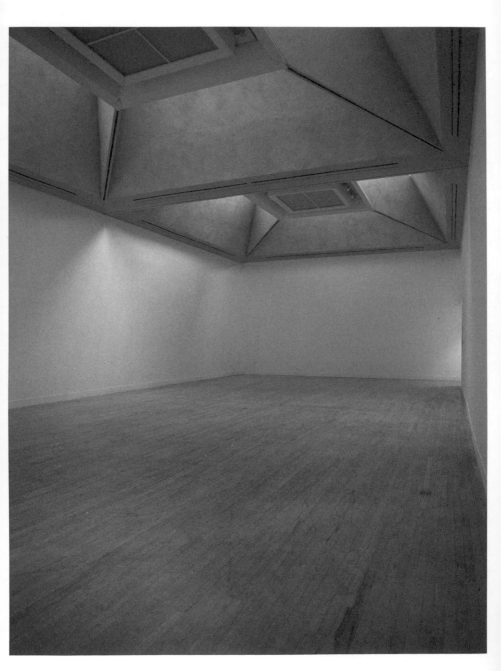

Martin Creed *Work No. 227: The lights going on and off* 2000
Materials and dimensions variable, courtesy the artist

GROWING UP IN PUBLIC: THE TURNER PRIZE AND THE MEDIA 1984–2006

MICHAEL BRACEWELL

If contemporary art is seen to threaten, amuse, exasperate or offend, then it is within the chilly shadow of such disdain that the Turner Prize, Britain's best-known award to a visual artist, has managed not merely to survive but to flourish. Indeed, the Turner Prize has managed to make a virtue of its reputation for controversy, transforming the very weight of its often ambivalent mediation into a far broader public awareness of the activities of contemporary artists.

Central to the history of the Turner Prize is the issue of criticism and critical language – the ways in which art is written about, and the language with which it is described and discussed. As a consequence of these concerns, much of the mediation of the Turner Prize has been based around a principal, endlessly renewed question: how might contemporary art account for itself?

Over the course of the prize's history, the work of the shortlisted artists and winners have provided a lucid commentary on the changing fashions, unpredictability, and mysterious ways of contemporary art. But the Turner Prize has also, through its exposure to and reflection in the increasingly ravenous forces of media, done much to make eloquent parallel shifts within the wider cultural sensibility. What emerges is a vivid patterning of trend, in which the art world, no less than the media, is seen to be in a constant, paradoxical state of simultaneous insularity, anxiety and self-examination.

Nearly a quarter of a century ago, when in 1984 Malcolm Morley was announced the first winner of the Turner Prize, the individuals, institutions and publications that comprised the contemporary art world in Britain seemed specialist and obscure. As they figured within the wider media, British artists – with the possible exception of David Hockney – were by no means considered celebrities; and those who were linked to the worlds of high fashion or aristocracy tended to be so behind a comparatively high wall of social exclusivity.

The populist convergence culture of celebrity and consumerism that would become so beloved of magazines and supplements across the entire demographic span of twenty-first century media, and in which contemporary art has become an increasingly vivid strand, was many years distant. Beyond publications such as *Andy Warhol's Interview Magazine*, with its insider gossip about the glamorous New York art scene, the art world was perceived as somewhat unknowable, and mired in its own parochial arguments. This perception was compounded by the fact that there seemed to be little dialogue, for the most part, between artists and the broader currents of contemporary culture.

Malcolm Morley *Farewell to Crete* 1984
Oil on canvas, 203.2 x 417, Private collection

Oh misery, Gilbert and George win art award

by Lynda Murdin

GILBERT AND GEORGE had a hangover today. It's not that they had been enjoying themselves—they say they never enjoy themselves.

Still, winning the £10,000 Turner Prize at the Tate Gallery last night meant that drink had been taken.

And they must have some satisfaction in being deemed by judges at the Tate to have made "the greatest contribution to art in Britain in the previous 12 months."

Yet George said today: "Nothing we do is lighthearted. We don't know anyone more miserable than ourselves."

But he did add: "It's very good for us. It's very good for our friends and supporters and it's even better for our enemies because it will disturb our opposition, and when people are disturbed they have to think again."

Desire

Despite the early hour and artistic human condition both he and Gilbert were dressed in neat suits and ties, as they always are.

It was a strange environment in which to find artists elevated to such a height—in

Spitalfields Market where they have lived for their 20 years together, in a street that has the Jack the Ripper pub at one end and Brick Lane at the other.

The suits symbolise their desire to be like everyone else. Perhaps it is the habit of fastening all three buttons on the jackets that make them look different.

"We are average, we are ordinary, uneducated lower class people. We don't like exclusivity in art, explained George, while Italian-born Gilbert nodded in approval.

Perhaps it is that that has given them so many enemies in the establishment. Gilbert, his voice accented, agreed: "There's hardly a name we haven't been called."

Asked if this concerned them, George leaned earnestly and asked: "If I say you are a rotter would you be affected?"

The head, the soul and the sex, they believe, are the three main life forces from which true art springs.

On critics, Gilbert added: "If you are English and alive they want to kill you."

Although judged to have made the biggest contribution to British art in the competition, Gilbert and George have mainly been exhibited abroad.

Evening Standard 26 November 1986

But this was also a time of substantial change within the British cultural media; and the wider context into which the Turner Prize was launched was one in which the critical distinctions between 'high' and 'low' cultural forms were increasingly under question. Throughout the first year of the prize – which saw the deaths of such emblematic national figures as the Poet Laureate, Sir John Betjeman, the comedian Tommy Cooper and the actor James Mason – there was also the sudden expansion of a new sub-cultural media, originally inspired, in part, by the widening cultural resonance of punk's assault on popular music.

Since 1977, when 'God Save The Queen' by the Sex Pistols was banned by the BBC during the summer heatwave of the Jubilee celebrations, there had been a mounting sense that the muniments of contemporary culture – the vivid shards of phenomena that comprised a postmodern condition – were being analysed and enshrined from a new perspective. Consequent on shifts within journalism aimed at a younger generation, as glossy magazines such as *Tatler* and *Harpers & Queen* (the latter now with a specialist 'Style Editor', Peter York), began to exchange a portion of their aristocratic hauteur for a certain funky irony, so too would the establishment of young fashion and music magazines such as *i-D* and *The Face* announce a fresh sensibility.

Concerned on the one hand with the monitoring of trend, and on the other with the celebration of a new kind of street-chic cleverness, riding the mood swings of pop cultural style was ascribed an urgent gravitas: 'Identity counts more than fashion,' the editorial in the first issue of *i-D* declared in 1980, concluding, 'Make a statement, originate don't imitate, find your own I.D.'

At the heart of this new media was a keen interest in the effectiveness and nuances of visual culture of all kinds. The cult of self-recreation that reached right back (traditionally amplified in art schools) through the street styles of youth, and which had been evolved into a new mutant form by the stylistic audacities of punk, had created by the early 1980s a generation whose visual sophistication was matched by their fluency in the reading of modern media. The semiotic power of popular culture could now not only be deconstructed (for fun, almost), but also reconfigured in a way that played games with cultural status, sloganeering, commodity culture, revivalism and visual rhetoric.

So the first half of the 1980s would see in Britain a broader cultural situation, within which hitherto unaligned strands of creative activity would find themselves increasingly intimate. By mid-decade, which creative activity would more eloquently express the experience

of the modern world? A painting by Adrian Wiszniewski? A vast, cosmological picture by Gilbert & George? A new record by The Smiths? A clever television advert? Or the design of a new office building in the City? Such questions were not new, but the ways in which they were asked, and the language with which they were answered, was undergoing a significant change.

By way of an example: on the same day (10 November 1984) that the *Guardian* newspaper dismissed Malcolm Morley's winning of the Turner Prize as 'merely confirming the continuing cultural dominance of the New York art world,' the Number One spot on the UK Top Twenty was taken by Frankie Goes To Hollywood, with their second major release – in part a high-energy dance record, in part a political protest song – called 'Two Tribes'.

Frankie Goes To Hollywood were the creation of pop journalist Paul Morley, whose writing for the *New Musical Express* had achieved widespread recognition for its cleverness, eclecticism and wit, and would subsequently become one model for the tone, if not the style, of much broadsheet cultural journalism. Released on the ZTT label (its name a direct reference to Marinetti's Futurist sound poem of 1914, 'Zang Tumb Tumb', which Morley had established with producer Trevor Horn), FGTH were a bravura example of a sophisticated pop cultural concept that achieved vast mainstream commercial success. And in this they exemplified a broader trend.

As Tom Wolfe suggested in his determinedly contrary essay of 1975, 'The Painted Word', there was a sense in which the artisan commercial industries of the Pop age were more sophisticated – artistically – than the work of many contemporary 'fine' artists who were responding to the same concerns and making work in the same new urban society. However mischievous and reactionary a thesis, there was a central plausibility to Wolfe's basic idea – some evidence of which could be found in the fact that in the mid-1980s in the UK, the institutional mainstream of the contemporary art world seemed largely remote from the burgeoning postmodern condition within British culture and society.

Reflecting such a schism, the media response to the Turner Prize seems in retrospect to reflect a degree of critical confusion, the coverage being in turn loftily urbane, and almost determined to find fault. What resounds above all is the certainty with which the various pundits regarded – perhaps with justification – the establishment and parochial society of the British art world as a closed and exclusive shop.

Frankie Goes to Hollywood *Two Tribes* 1984
Music video directed by Godley and Crème

Henry Porter – later UK editor of *Vanity Fair* – writing in the *Sunday Times* of 11 November 1984, typified the media reaction: the inscrutability and pointlessness of the art ('three dustbins and a load of string,' Porter reported his usefully stereotypical cab driver as saying) was matched only by the elitism of the art world: 'This is partly to do with the huge gap in understanding between the public and modern art,' wrote Porter, 'but it is mainly because these occasions are so strange and elevated that they seem to have absolutely nothing to do with everyday life.'

In such a headlock of criticism, it seemed unlikely that the Turner Prize would succeed in pleasing anyone. It seemed born to become a kind of psychic lightning conductor for an entire spectrum of cultural disaffection and complaint. But what of the actual art? The succession of artists shortlisted for the Turner Prize comprised about as eclectic a range as one might imagine. And such variety (there was no remote kinship in style and intention between, say, Patrick Caulfield and David Mach, or Gilbert & George and Richard Deacon) somewhat confounded the by now routinely dissatisfied media response to the award.

The Turner Prize was accused of both resembling an uncritical demonstration of Hollywood film industry self-congratulation, and of bringing art into disrepute through the very process of shortlisting artists and deciding a winner. Of being too glossy, in effect. But in one sense, such rumblings were already so cosily familiar that they announced nothing more than business as usual within both the art world and the media.

The *Freeze* exhibition curated in 1988 by Damien Hirst pretty much reconfigured the public image of the British art world. Above all, it made art fashionable in a way that it hadn't really been since the mid-1960s, and on a much wider, more populist scale. But in 1995, when the generation of *Young British Artists* were well on their way to becoming the new establishment of British art, a speech by one of the presenters of the prize, the musician and ideologue Brian Eno, raised a whole new question.

Eno's complaint was not aimed at the Turner Prize itself; rather, he used the highly visible, live-broadcast occasion to suggest that the arts should take a lead from contemporary science in terms of describing their activities and ideas, and, more importantly, of finding a *language* with which to present themselves to the broader public. 'Why have the sciences yielded great explainers like Richard

Gilbert and George at the 1986 Turner Prize Ceremony

Dawkins and Stephen Gould,' asked Eno, 'while the arts routinely produce some of the loosest thinking and worst writing known to history?'

Delivered at a time when the new power-brokers of British art and culture were being mediated as a neo-Swinging London cast of celebrities, and when much 'Young British Art' itself had incorporated the entire process of mediation into its espousal of sensationalism and shock values, Eno's questions appeared doubly pertinent. Famed in the music world for the originality of his ideas as much as for his trans-disciplinary eloquence, Eno represented the very opposite of the YBA tendency (exemplified by that year's winner, Damien Hirst) to reject intellectualism.

Within the broader media, however, there was little willingness to further the discussion Eno had proposed. The author and critic Jonathan Meades, writing up the 1995 award ceremony in the *Daily Mail* on 3 December, found equal fault with Hirst ('the world has become inured to such tactics') and the presenter of the Channel 4 coverage.

This question of critical language, meanwhile – of how the visual arts are perceived to discuss themselves – has remained central to the vexed relationship between the Turner Prize and the media. On the one hand, the prize has been accused of courting too much publicity and media carnival; on the other, the discourse surrounding the shortlisted artists and their work is routinely accused of obscurantism and elitism.

In the late autumn of 2001, these twin concerns were put into such sharp relief that the circumstances of that year's Turner Prize might almost have been scripted as a comic novella by some latter-day Wyndham Lewis or Evelyn Waugh. For this was the year when a minimalist conceptual artist (Martin Creed), installed his *Work No.227: The lights going on and off* (2000) as his contribution to the Turner Prize display exhibition – and was subsequently presented the prize by pop singer Madonna, who chose to use obscene language in her presentation speech, as 'an act of defiance' against the nine o'clock watershed on live broadcasts. This was a double whammy for the media: outrageously audacious art and a foul-mouthed celebrity.

Barely any newspaper could find anything good to say about that year's Turner Prize, even as many revelled (and who could blame them?) in the self-scripted satire on modern art and media that Creed plus Madonna acted out so well. At the same time, more seriously, it was a situation which exemplified Brian Eno's argument that the visual arts had to find a way of presenting their concerns in a language

Brian Eno announcing the winner of the 1995 Turner Prize

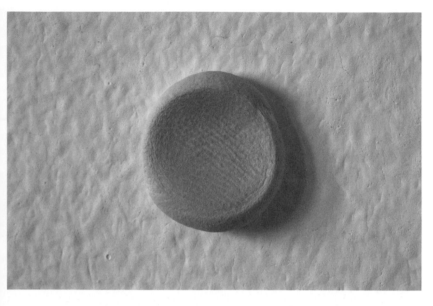

Martin Creed *Work No. 79: Some Blu-tack kneaded, rolled into a ball, and depressed against a wall* 1993
Blu-tack, approx. 1 cm in diameter, courtesy the artist

Madonna announcing the winner of the 2001 Turner Prize

that was both lucid and unreliant on obfuscatory critical jargon.

Ultimately it was this central collision – between art and the language of art criticism – that seemed most to alienate the wider media, and which had more than possibly, a few years earlier, determined that the lowest point in the mediation of contemporary art in Britain could be pinned down to a particular date: 10 July 1991.

This was the day on which an editorial in the *Sun* newspaper responded to a Channel 4 series, *Art Is Dead – Long Live TV*, in which a journalist called Muriel Gray attempted to prove by way of a television hoax that modern art and its supporters were guilty of fraudulence. 'In other words she spent a fortune stating the bleeding obvious –' proclaimed the *Sun*, 'that Modern Art is a culture-wrecking con.'

The delight with which Gray's programme attacked the very idea of contemporary art, and the speed with which the more influential tabloid press endorsed its cynical cause, were hard evidence of the enduring mistrust with which contemporary art was regarded by the populist British media. But more interesting than Gray's attempt to fool the cultural media was the motivation for making the programme in the first place. High on the programme-makers' list appeared to be a desire to expose as fake the standards by which contemporary art was appraised, and the language used for its appraisal.

Such territory was, and remains, central to both the Turner Prize and its mediation. As shown by the eclecticism and verve of the Turner Prize exhibitions, the shortlisted artists themselves wish for the most part simply to make their work; and then, if they accept the nomination for the Turner Prize, to allow that work to speak for them. What is whipped up around the artists, in terms of controversy, resentment, fashionability or exposure, seems finally to say far more about the critics of the prize, the media and critical language, than it does about the art itself.

The Turner Prize has grown from infancy to volatile adolescence at a time of astonishing cultural change. The speed with which cultural phenomena are identified, analysed, mediated, commodified, and converted into a received idea of themselves, has increased beyond measure. But art itself – as ably demonstrated, ironically enough, by Martin Creed's controversial *Work No.227* – retains a crucial ability to confound the pasteurising effects of mass-mediation. For all the ambivalence with which the Turner Prize has been regarded and written about since its creation in 1984, the art under scrutiny seems always to remain one step ahead – and for that alone deserves our applause and celebration.

ART SCHOOL EDUCATION AND THE TURNER PRIZE

SACHA CRADDOCK

The relationship between successful art and art education is complex. Obviously at a very literal level one leads to the other, but the relationship between the art student and Tate, for instance, is rather like that of a branch line to an intercity express. The effect of the Turner Prize on art-school education is equally hard to pin down. Over the last twenty years the Turner Prize coincided with a shift in British art which implied that the Tate Gallery had been closely involved with contemporary art all along, which it had not.

The British art schools have always had a fantastic reputation as a breeding ground for ideas and innovation, and are both oversubscribed here and in great demand from foreign students. The participants in art education – the students, tutors and various institutions in which they teach – have a wide range of relationships with Tate. The art student, so far down that line, might produce work *at* the moment, but would never be understood as producing work that is 'of the moment' – though a tutor might, in a few cases, have the opportunity to exhibit or curate at Tate.

Fine-art education has become academicised as the art school has melded into the university. Painting, sculpture, film, video and printmaking courses have also merged, and courses based on separate fine-art media are disappearing. A different set of principles and criteria for marking, exhibiting, teaching and accounting, as well as the alien notion of research, have arrived, along with the blurred distinction between university and polytechnic.

The last twenty years have seen a shift from the study of art history to cultural or contemporary studies accompanied by the idea that practical art can be studied in much the same way as anything else. Any challenge to this was seen as reactionary, with the forward-looking tutor becoming excited, flattered even, by the chance to be absorbed into the real and professional world of academia. This concentration on the academic brought a break in the perpetual questioning of the function and necessity of art, along with the emergence of a client economy for the student.

Such a change meant other university departments viewed the hour-long one-to-one tutorial, with the tutor rolling up a fag, sitting in appraisal of a miniscule change in an art student's work, as something of an indulgence. But basic principles still apply, and a fine-art student will always want to find ways to understand the context of their art, and need a certain level of criticism to question what they do and think. Anyone on a course needs to be taught. The idea that it is only a matter of producing preconceived work at this stage is a myth.

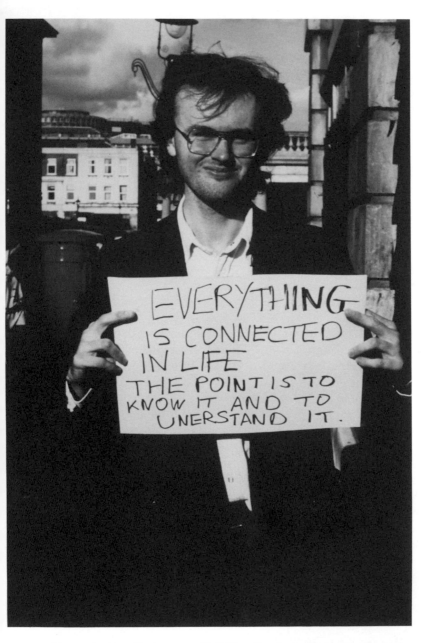

Gillian Wearing 'Everything is connected in life' from *Signs that Say What You Want Them To Say and Not Signs that Say What Someone Else Wants You To Say* 1992–3
Colour photograph, 119 x 79, Tate. Purchased 2000

The growth of media interest, the merging and change in use of different art forms and the play between public and private have all brought about a very different expectation of subject, meaning and decision. The student is expected to be super-conscious of an artwork as first and foremost a product of deliberate thought. Their verbal account has been brought more and more into play, as part of a greater dependence on the 'subject' of an art work as justification for its right to exist.

It is useful to ask whether such dramatic shifts are for the best; whether such an extension of the place and space in which to see art, and the column-inches generated about it, have resulted in greater trust and confidence in the art school. Most tutors will say that exactly the opposite has happened – that a free market economy perceives success as something that goes against the ethos of liberal art-school values. Often a case made for decent funding is now backed up with research 'points'; indicators of individual success, exhibitions and publications. Perhaps 'art for art's sake', a discredited notion, came to be equated with education for education's sake and therefore regarded as uneconomical. Art used to be considered separately from the notion of career, and studied in much the same way as English, with its ability to provide understanding and adaptability. Steadily over the 1980s the idea of 'professional development' was introduced, along with the shift in teaching away from art history and cultural studies and theory. The once defended gap between making, thinking, doing and subsequent career has disappeared. Art is now recognized as a product of our time, to be understood and intended by the maker and interpreted by the viewer. In fact the 'viewer' has become the real new recruit to art schools: someone always to be considered. Students are now expected to be both judge and defendant of their own work, to be inside the piece as well as strategically outside it.

As artistic success becomes more visible and more publicised, due in part to coverage of the Turner Prize, the understanding of art as something that can surprise the maker has also changed. Taking risks at art school, turning what you already do upside down, investing in a level of insecurity, is now deemed highly dangerous, risked only by a few. Now students and ex-students feel their work needs to be done *for* something, for a show especially. Tell an MA student that they have a certain amount of time to test what they really know before their final show, and their face will glaze over with panic and distrust: they only finally realise that the product, what the work will become, must be made and shown in order to exist. Whether group or solo, an artwork

or idea is just not viable without the exhibition, the pursuit of which will now include an equal line-up of curator, location and artist. The lonely artist working in the hope of attention and 'discovery' is perhaps something of the past.

The market openly and consciously entered the fray at the same time as there was a change in grants to art students. Instead of having a bursary to support them through college, many are now forced to work during the day to earn a minimal wage from bar or cleaning work. The role of the 'sensitive' artist has become the province of the better-off. The need to meet one's tutor between part-time jobs, and the frustration at missing a meeting to arrange next year's studio-space, can lead to a strained and semi-detached relationship with the school. Under New Labour, the student loan, with its subsequent painful hangover, illuminates this economic relationship: quite simply, work must sell. It is not unusual now for dealers to come into the art school while the student enters into an economic relationship with outside employers. It is the clever student, perhaps, who is aware that he or she must 'save themselves' for the right kind of market.

All this has accompanied a changing relationship between the public and contemporary art. Fuelled by the media, there has been a steady growth of interest in, and acceptance of, contemporary art which in the mid-1980s was still considered as marginal as poetry. This means that the artist, if not the artwork, is thought of in the same way as the musician or film star in terms of responsibility for popular culture. It could be said that art has been seen to change from self-expression to something for the public. It has moved from being of and about an internal dialogue to a matter of display.

There used to be, in the mid-1980s, massive conflict between the lyrical expressionists, minimalists, conceptualists; these different groups had bases in art schools up and down the country. You could tell where someone was studying at a very early stage, by their work. Now that has changed: the tutor is either successful or separate, the student more or less aware of status in terms of career rather than an ideological position. Just as money and career were not talked about at art school in the 1980s, so your tutor's career was not openly considered either. In a provincial art school, the tutors had their own, perhaps small, range of strongly held beliefs, from the 1970s' Coventry 'anti-painting' stance of Art and Language, to the strongly opposite attitude towards sculpture in 1990s' Winchester (which was seen as an outpost of the practice long abandoned at St Martin's). The particularities of the regional art schools, providing a strong sense of identity and unity,

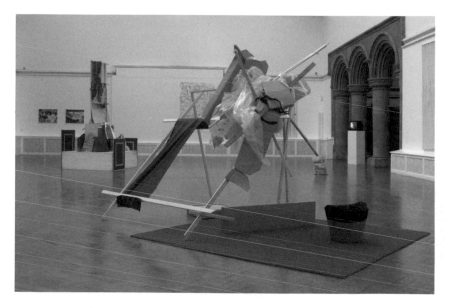

2006 Manchester Metropolitan University MA exhibition, featuring work by Susan Massey, Rebecca Davy, Lucy Smith

Malcolm Morely with his painting *Farewell to Crete* 1984

have now largely been ironed out by a heightened consciousness of professional success and the availability of information. Throughout the country, art schools used to talk of instituting 'theory', but while the more distant colleges were bringing it in, Goldsmiths, having been the first to introduce this mode of teaching, had already turned its back on the wholesale consumption of philosophy alongside the production of work.

So much has changed for the art student over the last twenty years in terms of the coverage of art. Even up to ten years ago, an art student would study the pages of an international art magazine and attempt to understand medium and meaning, or indeed the scale of a work; its colour and form. The internet has changed that. A contemporary artist can be referenced immediately, if only in a bite-sized, bulleted manner. There was an actual point in time when only the famous and well-known were brought over into the contemporary internet age. And less well-known artists, even recent ones, won't necessarily be on the web at all, so because of new technology there is already a gap in our knowledge, a break between old and new. This has left a false gap in broader artistic development and consciousness as defined by the internet.

The Turner Prize has also engendered increased press coverage, along with the short films shown on Channel 4 about each artist, which gave the students a sense that these artists were close to them, and of the same age. It was set up to popularise art and bring it to the general public. In the 1990s, an annual panel discussion was held at art centres like Cornerhouse in Manchester, which brought together spokespeople, critics, curators and directors of institutions around the country to debate the prize. The session would usually start with the short films on the artists, then be opened up for discussion by the panel. Each speaker would be given an artist to cover, but mainly the very point of the prize, the 'political agenda', would dominate the discussion. Comments such as 'It's all sewn up,' 'Nick Serota makes the decisions,' and other urban myths were common. The Tate would organise and pay for the discussions, the audience consisting of interested parties and a large proportion, always, of art students.

Ambition carries with it a ready-made picture of success, which becomes more and more uniform as the media coverage increases. The idea of a prize has changed attitudes to art; the simple process of attention to something so singular has managed both to encourage young artists and confine ambition and dampen curiosity. The notion of a prize introduced as a popular device has necessarily

Matt Hope *Superstructure* 1999, Installation from Winchester School of Art BA graduating class

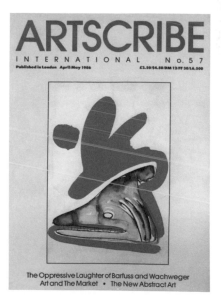

Artscribe International, no.57, April-May 1986

Rebecca Warren speaking about her work for the 2006 Turner Prize

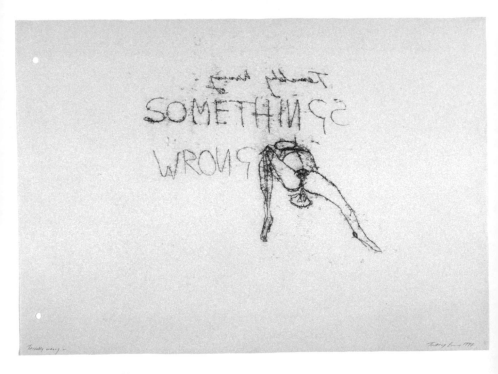

Tracey Emin *Terribly Wrong* 1997
Monoprint on paper, 58.2 x 81.1, Tate. Presented by the Patrons of New Art (Special Purchase Fund)
through the Tate Gallery Foundation 1999

reduced the idea of success to one of economics and celebrity. The generation most associated with the Turner Prize, that of the 1990s, provided an over-simplified, branded version of the state of British art, like an advertising campaign by New Labour and the London tourist board. The Turner Prize became the subject of dinner-party conversation. People outside the art world had opinions, but all was reduced to who should win. It was intended to be the equivalent of the Booker Prize for art, yet the difference between a novel and an exhibition is that a novel provides a one-to-one experience, while an exhibition depends more on its notoriety than its experience.

If an art student is well taught, they can visit the prize and still use the work to open discussions on ideas and possibilities. It can be difficult for a tutor, though, who simply doesn't understand why a particular work is successful. In response to the initial diarist, school-girl confessions in the early days of Tracy Emin, for instance, large numbers of young female students, suddenly found themselves encouraged to 'run away and do their own thing' by male tutors who would in the past have at least questioned the value of uncritical autobiographical expression.

Because it is a competition, the Turner Prize encourages a somewhat restricted view of art, which most art students will dismiss. They already feel they understand what makes it tick, and think they can guess who will be on the shortlist. It has even become something of a sport, the Grand National of the art world – with just as many injuries.

LOUISA BUCK

1 Louisa Buck, *Market Matters: The Dynamics of the Contemporary Art Market*, Arts Council England 2004, p.19.

2 These included *Three Los Angeles Artists- Larry Bell, Robert Erwin and Doug Wheeler* 6-31 May 1970; Claes Oldenberg 24 June-16 Aug 1970; *British Painting and Sculpture 1960-1970* 12 Nov 1970-3 Jan 1971; Andy Warhol 17 Feb-28 March 1971; Robert Morris April-6 June 1971; *The Alistair McAlpine Gift* 30 Jun-22 Aug 1971; Dennis Oppenheim 2000 Shadow Projection 28 Jun-16 Jul 1972; *Video Show: Illustrations by Tamara Krikorian, Brain Hoey, Stuart Marshall, Davis Hall, Steven Partridge and Roger Barnard* 18 May-6 Jun 1976; Marcel Broodthaers Films 9 Feb-19 Feb 1977; Richard Long 16 Jul 1979-1 Apr 1980

3 The most significant exhibition of contemporary art of this period was *New Art* curated by Michael Compton, 14 Sept-23 Oct 1983.

4 *The Tate Gallery 1982-4 Illustrated Biennial Report*, p. 9.

5 *The Tate Gallery 1982-4*, p. 15.

6 *A Proposal to Establish a Tate Patrons of New Art*, press release May 1982.

7 Alan Bowness, statement 26 May 1982.

8 Alan Bowness, quoted in Virginia Button, *The Turner Prize*, Tate Publishing 2005, p. 20.

9 Oliver Prenn interviewed by Louisa Buck, 9 January 2007.

10 Virginia Button, pp. 18-19.

11 Oliver Prenn interviewed by Louisa Buck.

12 1987 Turner Prize shortlist: Patrick Caulfield, Helen Chadwick, Richard Deacon (winner), Richard Long, Declan McGonagle, Therese Oulton. 1988 Turner Prize unpublished shortlist: Tony Cragg (winner), Lucian Freud, Richard Hamilton, Richard Long, David Mach, Boyd Webb, Alison Wilding, Richard Wilson. 1989 Turner Prize list of commended artists: Gillian Ayres, Lucian Freud, Richard Long (winner), Guiseppe Penone, Paula Rego, Sean Scully, Richard Wilson.

13 The 1985 Turner Prize shortlist included Milena Kalinovska, Exhibitions Director, Riverside Studios; the 1986 shortlist included film-maker Derek Jarman; the 1987 shortlist included Declan McGonagle, Director of the Orchard Gallery, Derry.

14 Virginia Button, p. 26, quotes a letter from a 1986 Turner Prize juror to Alan Bowness which states: 'I am disturbed to learn that the artists have been offered 11ft of wall space, again in the rotunda, to be approached by a tunnel through a building site.' Nicholas Serota, in a letter to Waldemar Januszczak 17 July 1990, wrote: 'the practice of presenting an exhibition of work by shortlisted artists was dropped in 1988 because past exhibitions had been flawed by an inconsistent representation of artists' work caused by the difficulties of obtaining appropriate loans ... or by the impossibility of recreating, in the time and space available, the installations or time-based works for which artists had been nominated.'

15 Nicholas Serota interviewed by Louisa Buck, 10 January 2007.

16 Nicholas Serota, letter to Alan Bowness 13 April 1988.

17 Nicholas Serota, letter to Waldemar Januszczak, 17 July 1990.

18 Matthew Collings, *The Late Show* 1990, broadcast BBC 21 November 1990.

19 *Aims of The Gallery: The Tate Gallery Biennial Report*, 1988-90, p. 12.

20 Ibid., p. 13.

21 Trustees Foreword, ibid., p. 8.

22 Waldemar Januszczak, letter to Nicholas Serota 22 June 1990.

23 Nicholas Serota, interviewed by Louisa Buck.

24 Ibid.

25 As well as *Freeze*, curated by Damien Hirst in Surrey Docks in 1988, other group exhibitions organised by young British artists in disused London warehouses included *Modern Medicine, Gambler and Market*, all in Building One, Bermondsey 1990; East Country Yard, South Dock, London (1990); and three shows at Clove Building, Bermondsey, London (1991-2).

26 Among the dealers and curators who emerged to work with their artist contemporaries during the 1990s were Jay Jopling, Sadie Coles, Andrew Renton, Carl Freedman and Gregor Muir.

27 The Saatchi Gallery's first exhibition (March-October 1985) showed work by Donald Judd, Brice Marden, Cy Twombly and Andy Warhol. Between December 1985 and February 1992 the artists featuring in the gallery exhibition programme included Carl André, John Chamberlain, Dan Flavin, Sol Lewitt, Robert Ryman, Frank Stella, Anselm Kiefer, Richard Serra, Ashley Bickerton, Robert Gober, Jeff Koons, Peter Halley, Leon Gollub, Philip Guston, Sigmar Polke, Eric Fishl, Robert Mangold, Bruce Nauman, Cindy Sherman, Mike Bidlo, Manuel Ocampo and Andres Serrano.

28 *Young British Artists I* (March–October 1992):
John Greenwood, Damien Hirst, Alex Landrum,
Langlands & Bell, Rachel Whiteread; *Young
British Artists II* (February–July 1993): Rose
Finn-Kelcey, Sarah Lucas, Marc Quinn, Mark
Wallinger; *Young British Artists III*
(February–July 1994) Simon Callery, Simon
English, Jenny Saville; *Young British Artists IV*
(April–June 1995): John Frankland, Marcus
Harvey, Brad Lochore, Marcus Taylor, Gavin
Turk; *Young British Artists V*
(September–December 1995): Glenn Brown,
Keith Coventry, Hadrian Pigott, Kerry Stewart;
Young British Artists VI (September– December
1996) Jordan Baseman, Daniel Coombs, Claude
Heath, John Isaacs, Nina Saunders.
29 Nicholas Logsdail, interviewed by Louisa
Buck 18 January 2007.
30 Among the many non-YBA artists shortlisted
for the Turner Prize between 1991 and 2000
were: Alison Wilding; David Tremlett; Sean
Scully; Shirazeh Houshiary; Callum Innes;
Craigie Horsfield; Christine Borland; Tacita
Dean; and Steven Pippin.
31 Trustees Foreword, *Tate Gallery Biennial
Report 1992-4* p.8.
32 The first Christie's Contemporary Sale, held
at Berry House, 148 St John St, London EC1, was
on 22 April 1998.
33 Nicholas Serota interviewed by Louisa Buck.
34 The 1994 nomination form states that 'for
the purposes of the Turner Prize, 'British'
applies to British born artists working in the
United Kingdom and abroad and to foreign
born artists living and working in the United
Kingdom, even if not naturalized citizens'. This
clarification followed the nomination of Irish
born Sean Scully and Laos born Vong
Phaophanit, the previous year.
35 The statement by Junior Arts Minister Kim
Howells on the public comments board at the
2002 Turner Prize exhibition: 'If this is the best
that British artists can produce then British art
is lost. It is cold, mechanical, conceptual
bullshit. The attempts at contextualisation are
particularly pathetic and symptomatic of a lack
of conviction,' was widely reported at the time.
36 In 2006 Frieze Art Fair attracted some
63,000 visitors.

TOM MORTON

1 Stuart Morgan, 'The Turner Prize: Stuart
Morgan on the Art World's Grand National',
frieze, issue 1, Nov/Dec 1991, p.11.
2 *Turner Prize*, exh.cat., p.13, Tate Gallery 1986

TURNER PRIZE
1984–2007

SHORTLISTED ARTISTS (Winner in bold) *Non-artists (curators, critics, film-makers)	JURORS
1984 Richard Deacon Gilbert and George Howard Hodgkin Richard Long **Malcolm Morley**	Rudi Fuchs *Director, Van Abbesmuseum,* *Eindhoven* John McEwan *Art consultant to Sunday Times* Nicholas Serota *Director, Whitechapel Art Gallery* Felicity Whaley-Cohen *Chairman, Patrons of New Art* Alan Bowness *Director, Tate Gallery (1980–8)*
1985 Terry Atkinson Tony Cragg Ian Hamilton Finlay *Milena Kalinovska **Howard Hodgkin** John Walker	Max Gordon *Architect, Patron of New Art* Mark Francis *Director, Fruitmarket Gallery,* *Edinburgh* Lynne Cooke *Lecturer in History of Art,* *University College London* Kynaston McShine *Senior Curator, MoMA, New York* Alan Bowness
1986 Art & Language (Michael Baldwin and Mel Ramsden) Victor Burgin **Gilbert & George** *Derek Jarman Stephen McKenna Bill Woodrow *Commended* *Nicholas Serota *Matthew Collings *Robin Klassnik	Frederick Ross *Patron of New Art* Jean-Christophe Ammann *Director, Kunsthalle Basel* David Elliot *Director, Modern Art Oxford* Michael Newman *Art critic and lecturer* Alan Bowness

1987	Patrick Caulfield	Oliver Prenn
	Helen Chadwick	*Patron of New Art*
	Richard Deacon	Kasper Koenig
	Richard Long	*Critic*
	*Declan McGonagle	Catherine Lampert
	Thérèse Oulton	*Senior Exhibitions Organiser,*
		Hayward Gallery
		Alan Bowness

1988	*Unpublished shortlist*	Richard Cork
	Tony Cragg	*Art historian and critic*
	Lucian Freud	Carmen Gimenez
	Richard Hamilton	*Director, National Centre for*
	Richard Long	*Exhibitions, Madrid*
	David Mach	Henry Meyric-Hughes
	Boyd Webb	*Director, Fine Arts Department,*
	Alison Wilding	*British Council*
	Richard Wilson	Jill Ritblatt
		Chairman, Patrons of New Art
		Nicholas Serota
		Director, Tate Gallery and
		Chairman of the jury

1989	*Commended shortlist*	Barry Barker
	Gillian Ayres	*Director, Arnolfini Gallery, Bristol*
	Lucian Freud	Bernard Blistene
	Richard Long	*Curator, Musée National d'Art*
	Giuseppe Penone	*Moderne, Paris*
	Paula Rego	Richard Dorment
	Sean Scully	*Art critic, Daily Telegraph*
	Richard Wilson	Evelyn Jacobs
		Patron of New Art
		Nicholas Serota

| 1990 | Prize suspended | |

1991 Ian Davenport Maria Corral
Anish Kapoor *Director, Museo Nacional Reina*
Fiona Rae *Sofía, Madrid*
Rachel Whiteread Andrew Graham-Dixon
Art critic, The Independent
Norman Rosenthal
Exhibitions Secretary, Royal
Academy of Arts, London
Adrian Ward-Jackson
Chairman, Contemporary Art Society
Penny Govett
Patron of New Art
Nicholas Serota

1992 **Grenville Davey** Marie-Claud Beaud
Damien Hirst *Director, Foundation Cartier pour*
David Tremlett *l'art contemporain, Paris*
Alison Wilding Robert Hopper
Director, Henry Moore
Sculpture Trust
Sarah Kent
Art critic for Time Out
Howard Karshan
Patron of New Art
Nicholas Serota

1993 Hannah Collins Iwona Blazwick
Vong Phaophanit *Curator*
Sean Scully Declan McGonagle
Rachel Whiteread *Director, Irish Museum of Modern*
Art, Dublin
David Sylvester
Art historian
Carole Conrad
Patron of New Art
Nicholas Serota

1994 Willie Doherty Marjorie Althorpe-Guyton
 Peter Doig *Director of Visual Arts, Arts Council*
 Antony Gormley Roger Bevan
 Shirazeh Houshiary *Patron of New Art*
 Jenni Lomax
 Director, Camden Arts Centre
 Milada Slizinska
 Curator and art historian, Centre
 for Contemporary Art, Warsaw
 Nicholas Serota

1995 Mona Hatoum William Feaver
 Damien Hirst *Art critic, Observer*
 Callum Innes George Loudon
 Mark Wallinger *Patron of New Art*
 Elizabeth Macgregor
 Director, Ikon Gallery, Birmingham
 Nicholas Serota

1996 **Douglas Gordon** Bice Curiger
 Craigie Horsfield *Editor, Parkett Magazine*
 Gary Hume Mel Gooding
 Simon Patterson *Writer and critic*
 Edward Lee
 Patron of New Art
 James Lingwood
 Curator and co-director of
 Artangel Trust
 Nicholas Serota

1997 Christine Borland Penelope Curtis
 Angela Bulloch *Curator, Henry Moore Institute*
 Cornelia Parker Lars Nittve
 Gillian Wearing *Director, Louisiana Museum,*
 Denmark
 Marina Vaizey
 Writer, art critic and lecturer
 Jack Wendler
 Patron of New Art
 Nicholas Serota

1998	Tacita Dean	Ann Gallagher
	Cathy de Monchaux	*Exhibition Officer, British Council*
	Chris Ofili	Fumio Nanjo
	Sam Taylor-Wood	*Curator and critic*
		Neil Tennant
		Patron of New Art
		Marina Warner
		Author and critic
		Nicholas Serota

1999	Tracey Emin	Bernard Bürgi
	Steve McQueen	*Director, Kunsthalle Zurich*
	Steven Pippin	Sacha Craddock
	Jane and Louise Wilson	*Writer and critic*
		Judith Nesbitt
		Head of Programming,
		Whitechapel Art Gallery
		Alice Rawsthorn
		Patron of New Art
		Nicholas Serota

2000	Glenn Brown	Jan Debbaut
	Michael Raedecker	*Director, Van Abbemuseum,*
	Tomoko Takahashi	*Eindhoven*
	Wolfgang Tillmans	Julia Peyton Jones
		Director, Serpentine Gallery
		Matthew Slotover
		Publishing Director, frieze
		Keir McGuinness
		Patron of New Art
		Nicholas Serota

2001	Richard Billingham	Patricia Bickers
	Martin Creed	*Editor, Art Monthly*
	Isaac Julien	Stuart Evans
	Mike Nelson	*Patron of New Art*
		Robert Storr
		Senior Curator, MoMA, New York
		Jonathan Watkins
		Director, Ikon Gallery, Birmingham
		Nicholas Serota

2002	Fiona Banner	Michael Archer
	Liam Gillick	*Critic and lecturer*
	Keith Tyson	Susan Ferleger Brades
	Catherine Yass	*Director, Hayward Gallery*
		Alfred Pacquement
		Director, Musée National d'Art
		Moderne, Centre Pompidou
		Greville Worthington
		Patron of New Art
		Nicholas Serota
2003	Jake and Dinos	Richard Calvocressi
	Chapman	*Director, Scottish National Gallery*
	Willie Doherty	*of Modern Art, Edinburgh*
	Anya Gallaccio	Frank Cohen
	Grayson Perry	*Patron of New Art*
		Chrissie Iles
		Curator of Film and Video, Whitney
		Museum of American Art, New York
		Andrew Wilson
		Critic and Deputy Editor,
		Art Monthly
		Nicholas Serota
2004	Kutlug Ataman	Catherine David
	Jeremy Deller	*Director, Witte de With Centre for*
	Langlands and Bell	*Contemporary Art, Rotterdam*
	Yinka Shonibare	Adrian Searle
		Art Critic, Guardian
		Robert Taylor
		Patron of New Art
		David Thorp
		Curator, Contemporary Projects,
		Henry Moore Foundation
		Nicholas Serota

2005 Darren Almond Louise Buck
 Gillian Carnegie *Contemporary art correspondent,*
 Jim Lambie *The Art Newspaper*
 Simon Starling Kate Bush
 Head of Art Galleries,
 Barbican Art Gallery
 Caimhin Mac Giolla Leith
 Art critic and lecturer,
 Modern Irish Department,
 University College Dublin
 Eckhard Schneider
 Director, Kunsthaus Bregenz
 Nicholas Serota

2006 **Tomma Abts** Lynne Barber
 Phil Collins *Writer, The Observer*
 Mark Titchner Margot Heller
 Rebecca Warren *Director, South London Gallery*
 Matthew Higgs
 Director and Chief Curator, White
 Columns, New York
 Andrew Renton
 Writer and Director of Curating,
 Goldsmiths College
 Nicholas Serota

2007 Zarina Bhimji Fiona Bradley
 Nathan Coley *Director, Fruitmarket Gallery,*
 Mike Nelson *Edinburgh*
 Mark Wallinger Michael Bracewell
 Writer and critic
 Thelma Golden
 Director and Chief Curator, Studio
 Museum Harlem
 Miranda Sawyer
 Freelance broadcaster and writer
 Christoph Grunenberg
 Director, Tate Liverpool

MICHAEL BRACEWELL

Michael Bracewell is the author of six novels and two works of non-fiction. He has written extensively on contemporary art, most recently contributing essays for Gilbert & George's *Major Exhibition* at Tate Modern, London, and Glenn Brown's exhibition at Gagosian, New York. His latest book, *Re-Make/Re-Model*, is published by Faber & Faber this October. He was a judge for the 2007 Turner Prize.

LOUISA BUCK

Louisa Buck is a writer and broadcaster on contemporary art. She is a contemporary art columnist for *The Art Newspaper* and a regular reviewer on BBC radio and TV. Her books include *Moving Targets 2: A User's Guide to British Art Now* (Tate 2000), *Market Matters: The Dynamics of the Contemporary Art Market* (Arts Council England 2004) and *Owning Art: The Contemporary Art Collector's Handbook* (co-authored with Judith Greer) (Cultureshock Media 2006) She was a judge for the 2005 Turner Prize.

SACHA CRADDOCK

Sacha Craddock is an independent art critic and curator. Curator for Sadlers Wells and co-curator for Bloomberg Space, she writes numerous articles and catalogue essays, gives many public lectures and is a respected post graduate tutor. She trained as an artist at St Martins and Chelsea but went on to write for the *Guardian* and then *The Times*. Craddock has judged the 1999 Turner Prize and the Jerwood Painting Prize and serves in numerous consultative and official capacities. Among other things she has recently helped to establish ArtSchool Palestine.

MARK LAWSON

Mark Lawson is a journalist, broadcaster and author. He presents BBC Radio 4's arts magazine *Front Row*. He has been a freelance contributor to numerous publications since 1984 and a *Guardian* columnist since 1995. In the mid-90s he presented *The Late Show* on BBC2 and has presented *The Late Review* since 1994. He has twice been voted TV critic of the Year and has won numerous awards for arts journalism.

TOM MORTON

Tom Morton is a writer and curator, educated at the Courtauld Institute, London. He is currently Curator of Cubitt Gallery, London, and a Contributing Editor of *frieze* magazine. The author of numerous magazine pieces and exhibition catalogues, his current projects include a special exhibition entitled *How to Endure* for the 2007 Athens Biennial.

GRAYSON PERRY

Grayson Perry is an artist and a writer, educated at Braintree College of Further Education and at Portsmouth Polytechnic. Winner of the 2003 Turner Prize, Perry is best known for his ceramic works: classically shaped vases covered with figures, patterns and text. His chosen topics include autobiographical images of himself, his transvestite alter ego Claire, and his family, as well as references to political events and an investigation of cultural stereotypes.

LIONEL SHRIVER

An American writer resident in the UK for the last 20 years, Lionel Shriver is the author of eight novels, including the 2005 Orange-prize award-winning *We Need to Talk About Kevin* and *The Post-Birthday World* of 2007. Ms Shriver is also a journalist, writing regularly for the *Guardian*, the *Economist*, the *Daily Telegraph*, and the *Wall Street Journal*, among other publications.

PHOTOCREDITS